UNDERSTANDING
COLOR
IN PHOTOGRAPHY

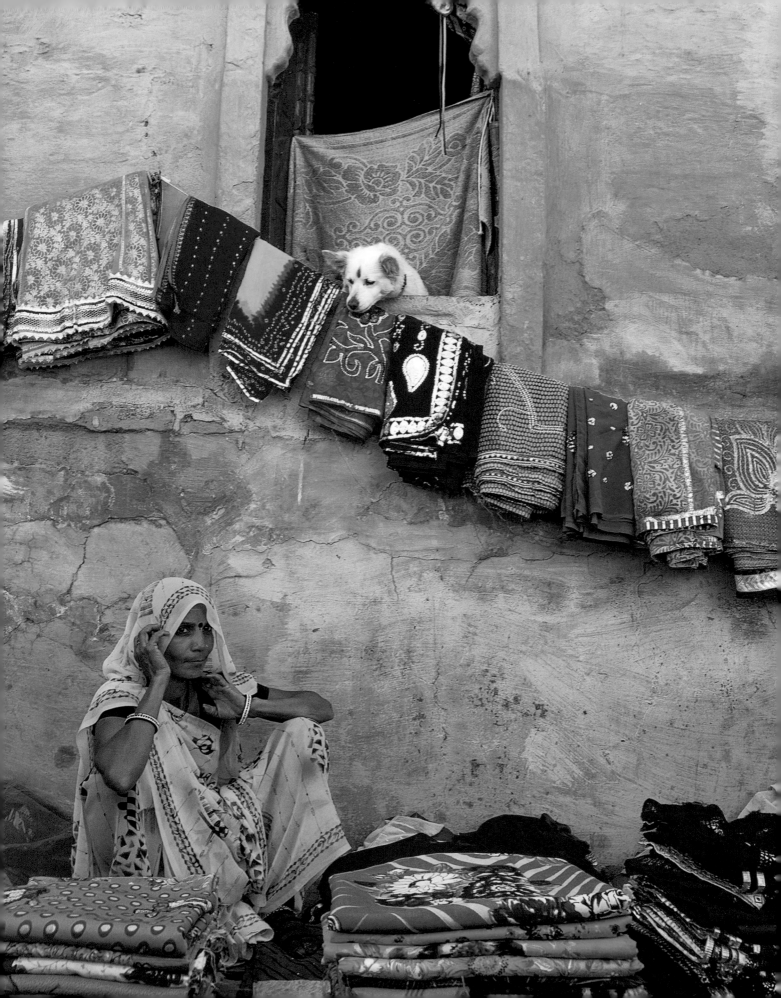

UNDERSTANDING COLOR
IN PHOTOGRAPHY

Using Color, Composition,
and Exposure to
Create Vivid Photos

BRYAN PETERSON

WITH SUSANA HEIDE SCHELLENBERG

WATSON·GUPTILL
CALIFORNIA | NEW YORK

Thank you to Justin, Chloe, and Sophie for the amazing color you have brought into my life!

Acknowledgments
I would like to thank the two most wonderful people at Ten Speed Press, Kelly Snowden and Jenny Wapner, who evidently believe that I still have something to contribute to the photographic community, and to the most amazing editor and friend, going all the way back to our time together at Watson-Guptill, Julie Mazur Tribe. It's a true honor to work with you again, Julie.

Photographs pages 6, 12, 13, 20, 42, 46, 70, 71, 75, 79, 87, 94, 96, 105, 118, 119, 133, 134, and 135 © Susana Heide Schellenberg

www.crownpublishing.com
www.watsonguptill.com

WATSON-GUPTILL and the WG and Horse designs are registered trademarks of Penguin Random House LLC.

Library of Congress Cataloging-in-Publication Data is on file with the publisher.

Trade Paperback ISBN: 978-0-770-43311-6
eBook ISBN: 978-0-770-43312-3

Printed in China

Design by Chloe Rawlins and Debbie Berne

10 9 8 7 6 5 4 3 2 1

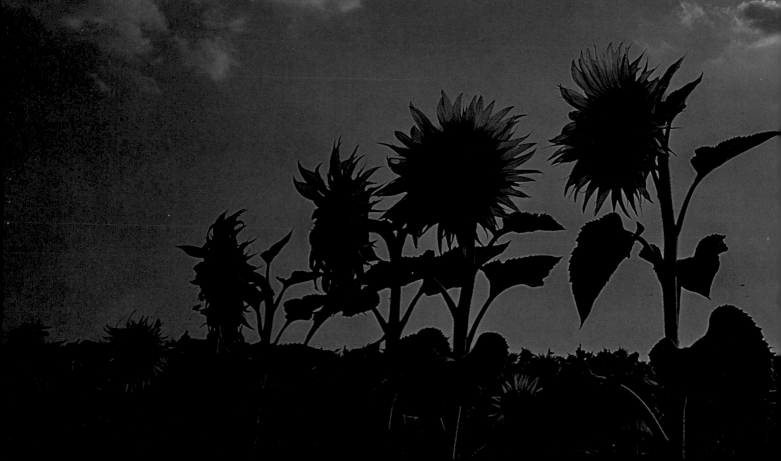

CONTENTS

INTRODUCTION 1

LIGHT, EXPOSURE, AND COLOR
Light and the Science of Color 12
Exposure and Color 18
White Balance and Color Temperature 22

COLOR AND COMPOSITION
Using Color for High-Impact Images 32
The Color Wheel 37
Complementary Colors 41
Analogous Colors 48
Monochromatic Colors 50
Color and Visual Weight 52
Using Color as a Seamless Background 60
**Using Motion: The "Brushstrokes"
 of Color** 66

COLOR AND MOOD
The Psychology of Color 74
Red 75
Orange 82
Yellow 90
Green 96
Blue 102
Purple 110
White 116
Black 120

USING TOOLS TO ENHANCE COLOR
Filters 126
Photoshop 130

Index 136

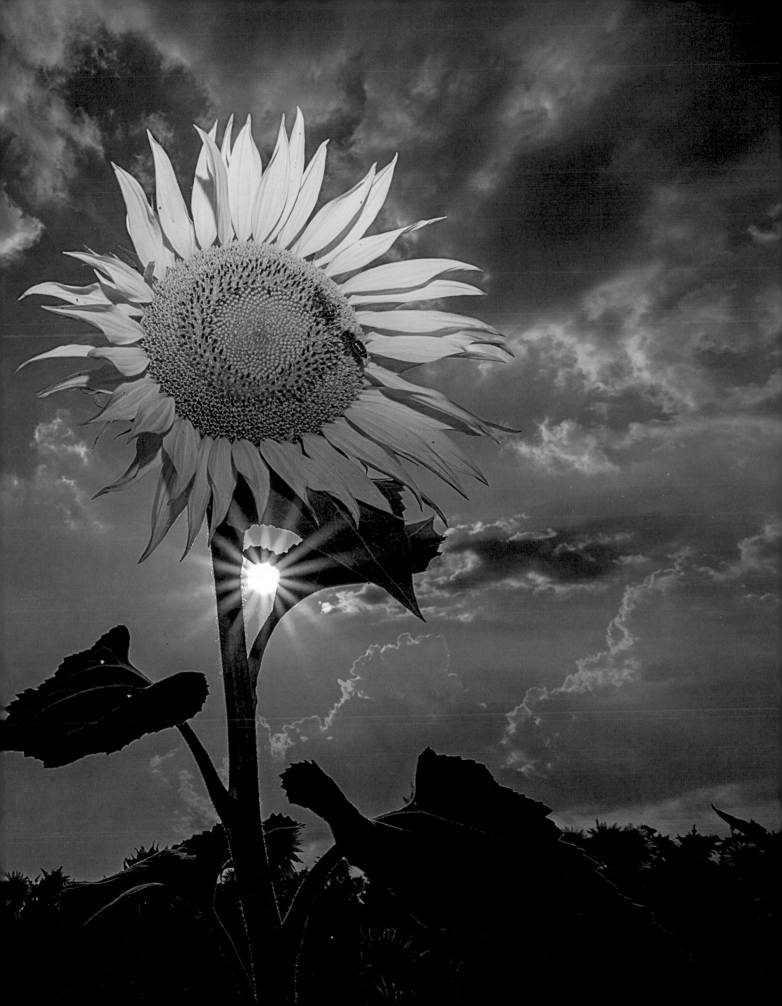

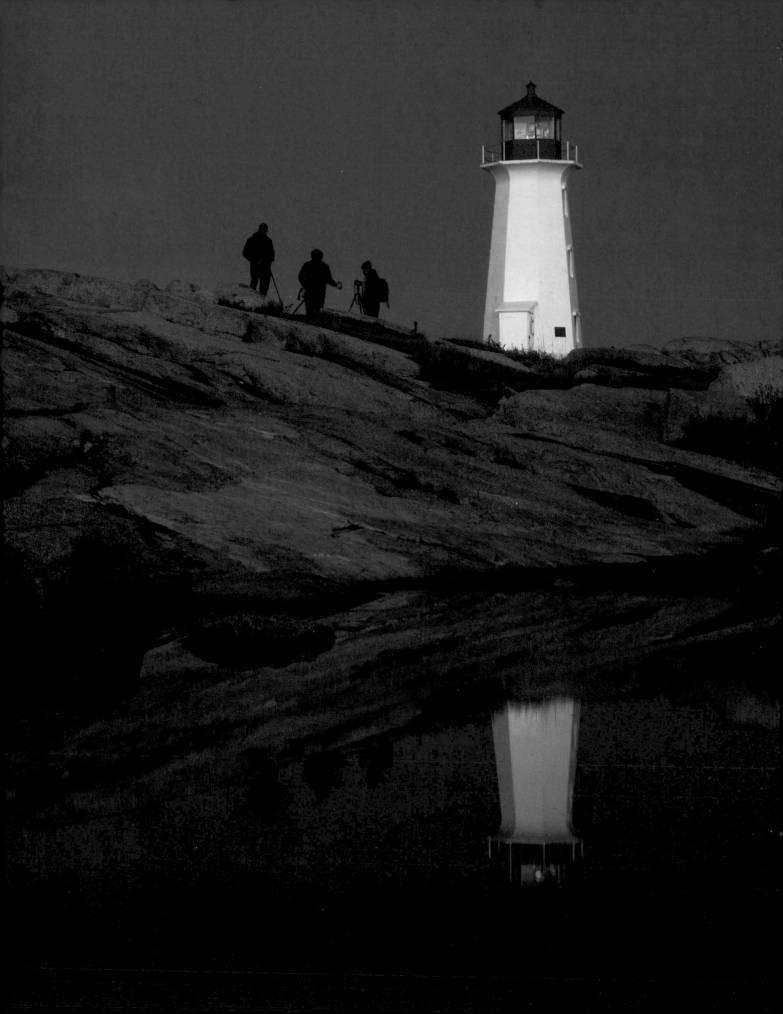

INTRODUCTION

When I first launched my dream to be a professional photographer back in the early 1970s, I began as most did at that time: by shooting with the less expensive black-and-white films. I had my own darkroom, which meant that I was also processing all of my own black-and-white film and making prints of the best shots.

Six months after I exposed my first black-and-white photograph, I walked into the local camera store in Salem, Oregon, and was delighted to find seven rolls of outdated film sitting in a half-price basket on the countertop. I quickly grabbed all seven rolls, paid the salesperson around fourteen dollars, and headed out the door, gleeful at the money I had saved and in anticipation of a camping trip that weekend, when I would surely shoot all seven rolls.

After my return on Monday, I was visiting my brother—the one who inspired me to get into photography in the first place—and shared the fun I'd had shooting all seven rolls. I laid them out on his kitchen counter, asking whether I needed to take any extra steps to process the outdated film. He looked at them and quickly said, "You can't process any of these rolls because they're not black and white. This is color slide film!" I was stunned. As far as I was concerned, a slideshow was the last thing I wanted to make. I was sure the compositions from the camping trip had been my best work yet, but now they would never be the amazing black-and-white images I had hoped to print. Seeing my crestfallen face, my brother pointed out that it *was* possible to have prints made from color slides—it was just expensive and time-consuming. The wait could be up to one week and I, at the young age of eighteen, had yet to master the art of patience.

Days passed before my frustration subsided enough to return to the camera store with the seven rolls of Agfachrome 50 film. And several days later, I returned to pick up my slides after a long day's work as a maintenance man for the City of Salem. What happened next was truly a defining moment in my then-young photographic career. As I placed each slide across the camera store's light table, I was confronted with some truly remarkable color-filled compositions. The fields of wildflowers and the blue sky with white puffy clouds seemed to leap off the light table. A plate of sliced cucumbers and tomatoes (one of my meals on the camping trip) screamed with the vividness of complementary colors. It was transformative; I was awash in the tremendous power of color. Within minutes, I asked the camera-store owner if he had any more outdated film—if he did, I would take every last roll.

Unfortunately, he had no more, but he did offer an attractive discount if I would buy ten rolls at once, and an even better one if I would buy twenty (called a "brick" of film). Little did I know just how many bricks I would buy over the next thirty-plus years. My love for color photography had begun.

Soon after, I picked up an orange filter at the camera store and started using it to photograph sunsets and sunrises. And later, while fumbling through a cardboard box on the countertop of that same camera store, I discovered a deeply colored magenta filter and a deep blue filter. Although I never found much use for the blue filter, I had no trouble beginning my love affair with the magenta filter. It was remarkably useful when shooting during the predawn and twilight "blue hour," when the sun is below the horizon and the sky takes on

a predominantly blue hue, as well as for shooting cityscapes and landscapes.

I didn't realize it at the time, but choosing to shoot color slides forced me to work harder at getting everything done in-camera. When shooting black and white, I often did both dodging and burning in the darkroom, not to mention judicious cropping. But color slides had severe limitations. It wasn't possible to process the film myself, so the daily pressure—the challenge—was not only to use the best possible light and get the exposure right in camera, but also to determine the most effective

composition. It was critical to pay attention not only to lens choice, but also point of view. I soon became an expert on time of day, light, seasons, weather, and how to manipulate my exposure to generate the most appropriate and/or the most vivid colors. I learned about the power of red and why I preferred to shoot red on overcast days. I learned to never shoot portraits or nudes when front-lit or side-lit by low-angled (and very warm) sunlight—unless I wanted to deal with lobster-red skin tones. And I learned how to create pastel tones, diluting colors into something lighter, softer, more ethereal, by simply overexposing by one to three stops.

Thinking in color meant looking at weather reports more judiciously, anxious to learn of clear skies or excited to learn that a storm would be breaking up right at sunset. I began to embrace the expression, "Red sky at night, sailor's delight," which promises clear skies in the morning, as well as its complement, "Red sky in the morn, sailors be warned," which predicts rain on the way. Cloudy days lured me to the woods, forests, and jungles, where the softer light made exposures of the muted tones of green so much easier. Rainy, wet city streets were now irresistible reflectors of neon lights and the headlights and taillights of moving traffic.

Fast-forward to the digital age. In 2002, my thirty-two years of "old tricks" were suddenly confronted with photographic progress. Like an eight-year-old being pressured to grab hold of a rope swing and launch out over the river below, I was apprehensive about leaping into digital. Cautiously, I began to embrace digital photography and quickly discovered my favorite—and least favorite—aspects of the new medium. On the plus side, I was able to shoot countless images without the expense of buying bricks of color slide film, saving me hundreds of dollars each month. But I also noticed the absence of vivid colors in my exposures. (Keep in mind, I had been spoiled by such vivid slide films as Kodachrome 25 and 64, followed by the Fujichromes, Velvia 50, Velvia 100, and Kodak's E100 VS.) It was only when I discovered

Motor oil stains in a wet parking lot offer a kaleidoscope of color. No doubt you've seen such oil stains on rainy mornings before and never thought of stopping to take a photograph. Perhaps now you will?

Nikon D7200, Nikkor 18–300mm lens, ƒ/16 for 1/100 sec., ISO 800

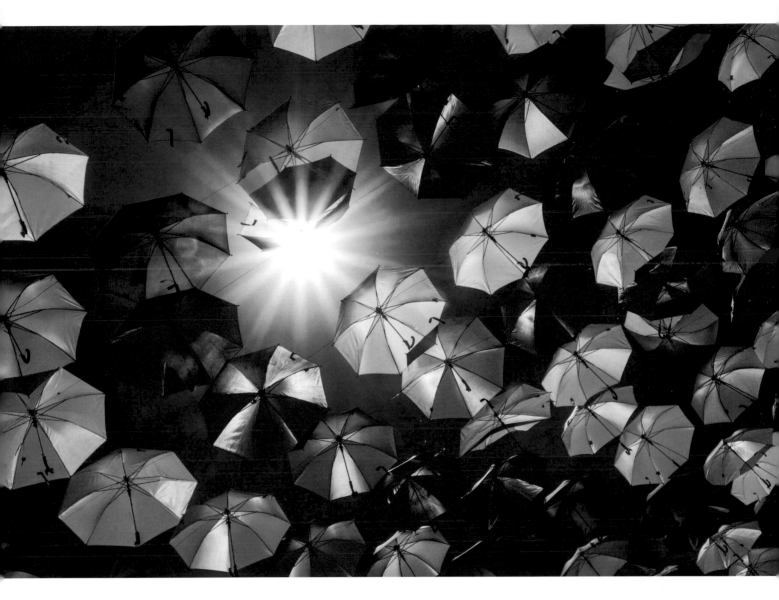

While out and about at midday in Guadalajara, I came upon this small street and looked up to find a number of umbrellas overhead. Like most of you, I'm not fond of shooting at midday as the light is colorless, just pure white light. But when you look up and find subjects that are backlit, that same light can be used to your advantage. Looking straight up at high noon is not much different from looking east or west at sunrise or sunset: you are shooting backlit subjects. And if the subjects are translucent, such as these umbrellas, you'll record colors all aglow! Note that I used the smallest lens opening, f/22, for a "starburst" effect from the sun.

Nikon D810, Nikkor 24–120mm lens, f/22 for 1/320 sec., ISO 400

Photoshop's Selective Color tool that I recovered the vivid colors of color slides.

I should mention now that this is not a book about postprocessing color. I do not suggest at any time that you partake in a number of time-consuming steps or lightning-quick actions in Lightroom or Adobe Bridge to produce vivid color. In fact, I give the topic of postprocessing color images only a few pages at the end of this book. Why? Because I am an advocate of getting composition and exposure done *in-camera*. It is possible today, just as it was in the days of film, to shoot a

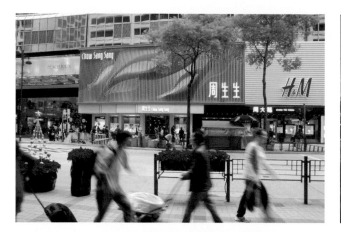

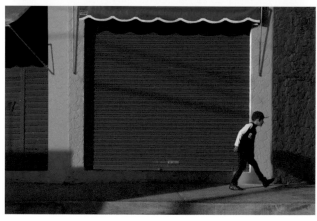

While in Hong Kong, I caught sight of this graphic gold and silver image above a jewelry store. There were hundreds of people on the street around me—including many with cameras on their shoulders—but so many were looking down at their phones, no one else seemed to spot it. If you're having trouble finding images around you, consider leaving your smartphone at home.

Nikon D7100, Nikkor 18–300 lens, *f*/13 for 1/200 sec., ISO 200

More often than not, when I stumble upon a colorful background or a subject that I find appealing—such as this closed-up butcher shop in Guadalajara—I will just sit down and wait for something to happen, such as a person or persons entering the scene. In this case, I sat on a curb diagonally across from the butcher shop and entered the "waiting place." Only twenty minutes later, I was rewarded when a young, colorfully clad boy passed in front. Rather than wander aimlessly looking for photos, consider taking up your street corner and allowing the image to come to you.

Nikon D810, Nikkor 24–120mm lens, *f*/8 for 1/200 sec., ISO 100

spectacular composition and a perfect exposure without ever resorting to photographic software, beyond some possible minor exposure tweaking and my recommendation of Selective Color.

It's true that cropping in Photoshop or Lightroom is the norm for many—as is manipulating brightness and contrast levels, shadows and highlights, and, of course, color. Nowadays there is a plethora of photo-software and plug-ins available to manipulate color, add texture, alter the lighting and the color of light, and crop at will. Before you know it, your original image has been transformed into what some might consider a stunning— yet hardly recognizable—one. This is not the "art of photography," in my humble opinion, but more akin to painting by numbers: a different thing entirely.

The fact is, there are certain fundamentals of photography that, at least for the time being, will continue to produce a shorter route toward photographic success. They include learning how to manipulate shutter speed, aperture, and ISO: the three elements of the "photographic triangle." These three fundamentals affect your image's exposure, brightness or darkness, and the visual weight of tones and color by increasing contrast, creating a high-key or low-key

effect, and dictating to viewers what is most important by the visual weight of focus.

When you combine this with a complete understanding of different lenses, from wide-angle to super telephoto, and the impact of point of view—such as knowing when to climb stairs and shoot down or lay on your back and shoot up; when to rent a bucket truck or a drone; and when to shoot through those bushes or out on that tree limb— you learn not only to see, but to photograph your *vision*. Chances are very strong that your vision is not hiding somewhere in Photoshop or Lightroom. Your photographic vision, which comes from within, is vitally important to your art of image-making. As an artist, *you* take responsibility for your vision, *you* own the creative process; the creative process does not own you! Your vision is inside you and is shaped by many factors, not the least of which is your love of color.

I am a color photographer. My approach to every image I shoot is almost always because of the color I see within that given subject. Many photographers define themselves by the subject they shoot: wildlife, fashion, wedding, events, industrial, sports, street, landscape, and so on. Other than weddings, I am passionate about photographing all of these subjects.

THE MARCH OF PROGRESS

Over the past fifteen years, the technology of digital photography has been moving at the speed of light. Cameras once considered on the cutting edge become dinosaurs within eighteen months. (Compare that to a film camera, such as the Nikon F-3, which for most of us was our go-to camera for up to seven years.) Fortunately, I think it's fair to claim that we have reached the summit of the technological mountain and finally have a moment to rest before conquering the next peak. Rather than seeing cameras with yet more

megapixel-laden sensors, I think we will begin to see sensors with a much higher dynamic range. This means that our exposures will soon be able to replicate the sixteen-stop range of light and dark captured by the human eye. As of this writing, the best camera out there, the Nikon D810, can see only about a nine-stop range. Note that I am not in favor of even higher dynamic ranges, as they will interfere with our ability to manipulate light and, subsequently, color in-camera— but that is a subject for another day.

(Shooting one wedding, years ago, was all it took, to convince me that I did not have the much-needed "diplomatic" personality to deal with everyone's idea of who was to be photographed and how they should be photographed.) Ninety percent of the time, I am drawn to a subject's color and the challenge of how to best present that color in the composition. I don't see a bird; I see its red wing. I don't see a landscape; I see a bright yellow flowering tree. I don't see a street scene; I see a purple door. I see color—and only after I see the color and imagine its arrangement do I even begin to think about the subject, whether it be a flower, a nude, a landscape, or a colorfully clad person waiting for the bus.

Doing a book on color photography was something I had thought about at various times over the past few years, but it was not until a workshop in Holland that this book started to take on momentum. During the workshop, a very talented photographer named Susana Heide Schellenberg asked in surprise why I had never done a book on *color*. Sometimes the obvious eludes me and that was certainly the case here. Color does define me, and because it also defines Susana, it seemed only

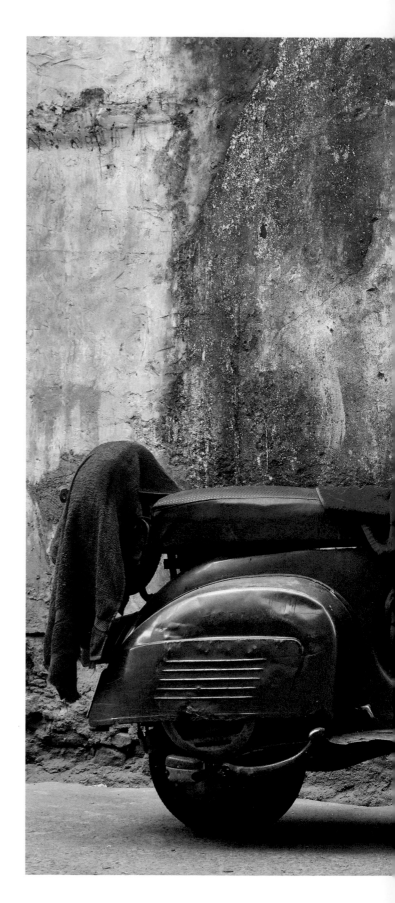

The city of Jodhpur in Rajasthan, India, is also called "the Blue City," known for its sea of bright blue houses. The houses are remnants of India's traditional caste system, painted blue by Brahmins to differentiate and elevate them from the other castes. Even though the caste system has weakened, the tradition of painting houses blue in Jodhpur remains. Happily, the city's blue houses and walls provide endless photo opportunities. So why am I describing blue houses when this image depicts a nearly colorless wall? Sometimes the best images happen when we deviate from the norm. As the other photographers in our group focused on much bluer houses, I wandered farther down the street and came upon this somewhat monochromatic, save for the bike and towels, scene. The clincher for me was the one contrasting red towel. —SUSANA

Nikon D7100, Nikkor 24-85mm lens at 35mm, *f*/6.3 for 1/200 sec., ISO 1000

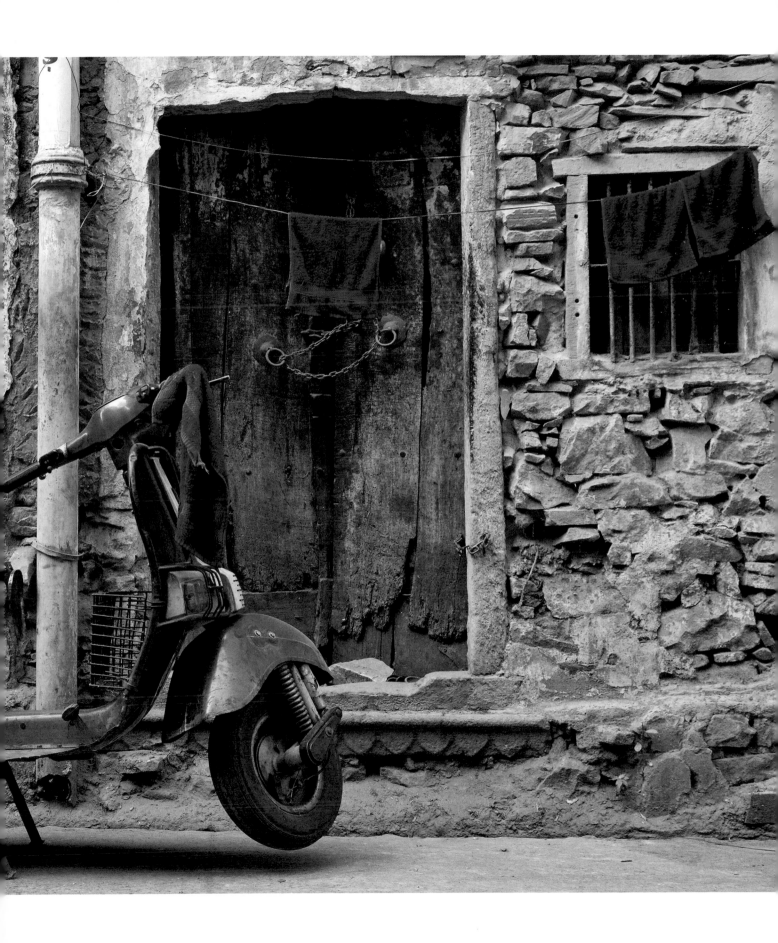

natural to make her part of this book. You'll find her images throughout, along with behind-the-scenes captions in her own words.

In *Understanding Color in Photography*, I strive to help you see and capture the vivid color in the world around you. We'll discuss the science behind why we see color, how your camera captures it, and tips for correctly exposing bright whites, dark blacks, and every color in between. We'll look at how color influences composition, and how to use color to your image's advantage. Lastly, we'll explore the *one* primary tool I use to enhance color in my digital images—Photoshop's Selective Color tool—as well as a few other color-transforming tools I call upon occasionally, including colored filters and Photoshop's Color Balance, Auto Color, and Replace Color tools.

As in all of my books, I've filled these pages with example images, extra shots showing the location and lighting of the images, and captions detailing the hows and whys of each capture. My intention is to help you expand your vision and to realize that much, if not all, of what you see in this book depended on all that I know about creating images inside that lightproof box commonly called a DSLR.

I want to stress that if your purpose in purchasing this book was to become well-versed in handling images *after* the exposure, and how to get the best possible color rendition with the aid of photo-processing software, then this book may not be for you. If, on the other hand, you believe that creating compelling images is something you can do with minimal photo processing, this book will surely answer that need.

LEARN TO SEE COLOR

When you go out to take photographs, what do you look for? As you walk along the streets of your neighborhood or city, are you drawn first toward the mannerisms of people or the color of their clothing, the colors that surround them, and the color of their hair? How good are you at spotting all of the color possibilities that abound within whatever photographic pasture you call home?

Depending upon where you live, and at what time of year you are shooting, different types and amounts of color will present. But no matter what, there is always color to be found. We are surrounded by color! And the first step to integrating better color in your photography is simply to train yourself to see it. One of the keys to expanding your vision is to stop looking at the world as filled with objects, or "nouns," and to look instead for line, texture, shape, form, pattern, and color.

To help you do this, here is an exercise I have suggested countless times over my many years of teaching photography. Set aside a couple of hours on any given weekend (or weekday, if you have time) and head out the door with the intention of photographing nothing but a specific color. For example, on the first outing, shoot nothing but compositions dominated by red. See how many red compositions you can discover. The next time, choose a different color, and so on.

By doing this, you will immediately expand your vision and start eliminating deeply held prejudices that keep you from seeing a great deal. And I promise, you will also have an incredibly fulfilling day of photographic discovery—perhaps unlike any you've ever had before.

Years ago, I was involved in a minor fender bender. Since the accident wasn't my fault, I wanted to take a picture of the small damage to my fender. As luck would have it, my camera and Micro Nikkor 55mm lens were in the trunk. I intended to take only one shot, but was soon immersed in the "beauty" of the damage. Not only was there some nice new texture (revealed by the paint that had been scraped off), but the other car had left a deep yellow mark atop what red paint remained.

Within a few days, I began seeking out more colorful macro images at local junkyards and wrecking yards. In one such outing, at a wrecking yard in Petaluma, California, I came upon an emblem for a Honda. Soon I was over the top of it, with my camera and Micro Nikkor 105mm lens. Because I was parallel to the emblem, I had no depth of field concerns so chose the "Who cares?" aperture of f/11 and simply adjusted my shutter speed until my camera's meter indicated a corect exposure of 1/160 sec. After firing several exposures, I decided to get even closer to

see how abstract I could go. In the shot you see here, I simply focused as close as I could get. My point of view was still parallel to the emblem, so I kept my aperture of f/11, but now my light meter indicated a slower 1/100 sec. shutter speed. Why? Because the lens was now extended further, so light needed more time to travel down the lens onto the sensor.

Most amateur and even professional shooters get so excited by their first macro lens that they fail to fully realize its close-focusing potential. In countless workshops, I'm invited by students to check out their close-up images, and when I suggest they get even closer, they'll ask, "How?" I simply tell them to keep focusing until they can focus no more. To their surprise, they discover just how close— really close—they can focus, thus opening up the real world of macro.

Nikon D300S, Micro Nikkor 105mm lens, f/11 for 1/100 sec., ISO 200

LIGHT, EXPOSURE, AND COLOR

LIGHT AND THE SCIENCE OF COLOR

The most vitally important element that goes into the making of each and every color we photograph is, of course, light. In the absence of light, we have utter darkness, pitch black. Light gives life to almost everything here on Earth, including color. There isn't a single green plant, red apple, golden grain, or purple lavender bush that can survive without light. Light is the beginning of the food chain. Light is responsible for chemical changes in our brain, it is responsible for cell growth, and it is responsible for creating color.

How does light influence color? First, let's imagine a pitch-black table upon which we will eventually compose a colorful composition. The only reason the table is pitch black is because there is no light whatsoever in the room. Before we put any objects on that table, we have to be able to see it, so we open a large window and *voilà*, we discover right

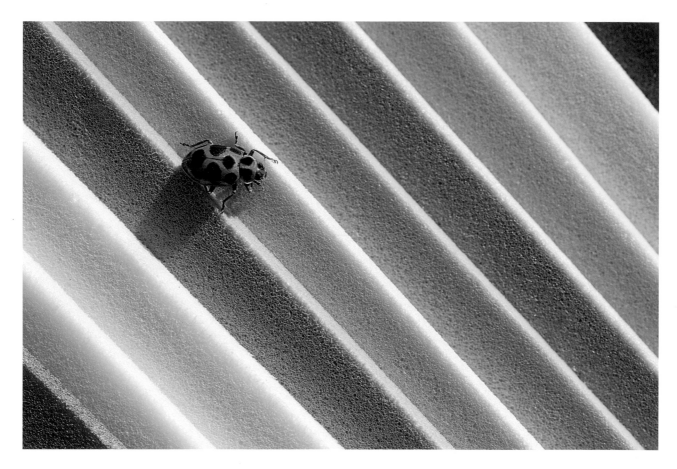

I made this rainbow backdrop with colorful foam sheets from a craft store; all that was missing was a hoped-for ladybug. At the time, my tomato garden was a haven for these aphid-eating insects and after only a few seconds in the garden, I had no trouble finding a willing model. I cupped her in my hand and carefully placed her on my backdrop.

To my utter amazement, she hung around for several minutes, allowing me plenty of time to get this shot. —SUSANA

Canon EOS 1D Mark II, Canon 50mm lens, *f*/8 for 1/60 sec., ISO 100

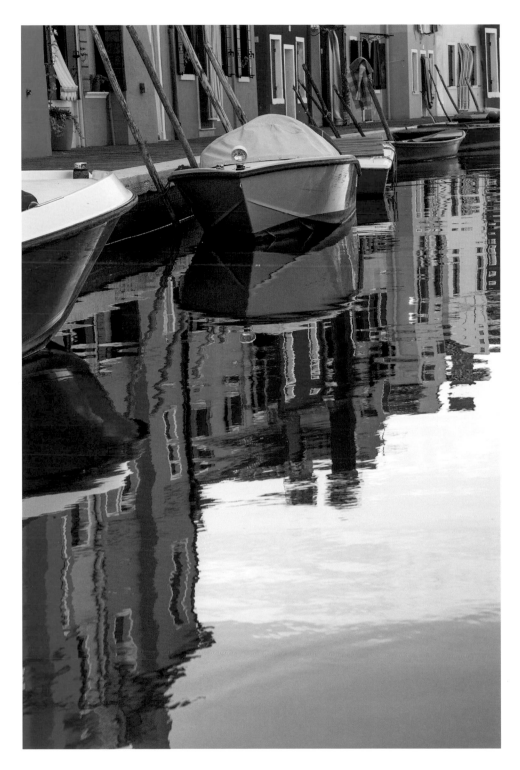

For those of you who have been to Burano, Italy, the colors in this image will come as no surprise. Legend has it that the island's colorful houses were painted by fishermen so that they could easily distinguish their own dwellings from afar as they returned from fishing trips. Canals run alongside the streets as a means of transportation, mirroring the houses and boats and providing countless photo opportunities. —SUSANA

Nikon D700, Nikkor 24–85mm lens, *f*/10 for 1/125 sec., ISO 250

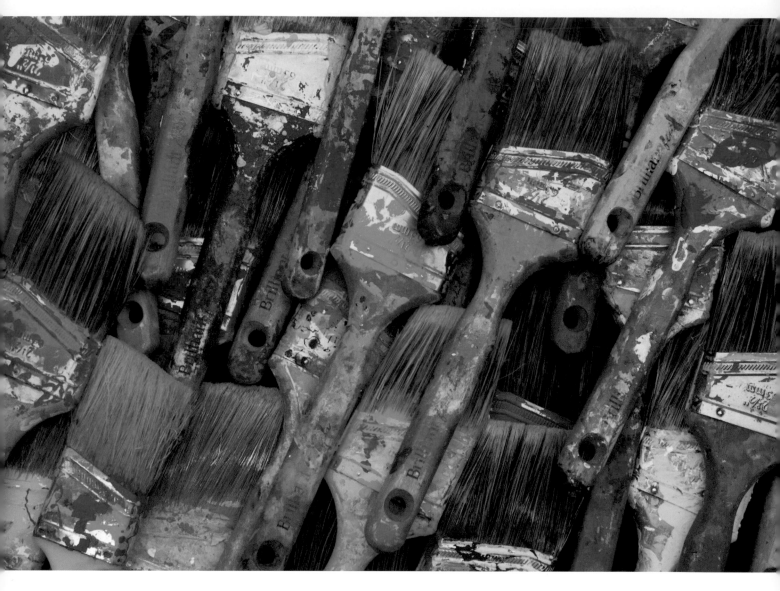

When I came upon this group of used and very colorful paintbrushes, I immediately thought of a food fight in a grade-school cafeteria. Look at this amazing display of "rejected" color!

Nikon D800E, Nikkor 24–120mm lens, *f*/11 for 1/200 sec., ISO 200

away that the table is not black at all, but white. We know it's white because we see that it's white, but why isn't it red, blue, or yellow?

Every single object not only absorbs light but also *reflects* some of it back. In effect, an object gives back, or returns, some of the light. And it is this giving back, this reflected light, that provides an object its color. The physical properties of each and every object, from plants to people, determine which color or colors are reflected and, in turn, seen by the human eye. What do I mean by an object's "properties"? If you'll allow me a bit of artistic license, I will explain.

Science 101 tells us that every object on Earth is made of molecules which are made of atoms that contain electrons (as well as protons and neutrons). But it's not until the introduction of light that these electrons, these atoms, and these molecules give us color, and here is why. Imagine that the transmission of light is akin to having an entire buffet of food delivered to your home. In a short amount of time, we would be able to determine which foods you like and which foods you don't like based on which you ate and didn't eat. For example, at the end of your meal, I would be able to see that you like roasted chicken, rice and beans, corn on the cob, and apple pie, because none of those foods remained (since you *absorbed* them). I would also see that you have no interest in meatloaf, baked potatoes, beets, and tapioca pudding, since those things remained (and were not absorbed by you). In effect, you rejected—or *reflected*—those foods.

Okay, so now imagine that all visible light is such a delivery service. For fun, let's call this service Rainbow Delivery, with the slogan, "Without me, you will remain in the dark!" Every day, Rainbow Delivery shines its extensive buffet of light on every object on Earth and in the sky, and of course

the menu includes red, orange, blue, yellow, green, purple, as well as black and white light and millions of shades, tints, and tones in between. And just like you and your appetite, every object has a hunger for only specific colors of visible light. Whatever light that object doesn't "eat" (meaning, does not absorb), is reflected back as a color, which our eyes can then see.

We see a yellow banana because the atoms, molecules, and electrons that make up a banana gobbled up all of the other colors of light, having no taste for yellow. The same can be said for an orange or a green apple. We see orange and green because the orange and apple's properties have *no* appetite for those two colors of light, and thus reflect them back.

Are you thinking what I am thinking? A red rose is only red because the properties of that rose have a huge dislike for red! The sky and the oceans are blue because the sky and ocean dislike blue. Yes, I am taking artistic license to make my point, but it is a fact that objects have no color without light and also that, when those same objects are lit, the color we see is "rejected" color. The object has no appetite for that specific color or tone of light.

If we break this down even further, we can add that white has the greatest appetite of all, since it results from mixing equal amounts red, green, yellow, and blue light waves. Conversely, the color black has very little appetite and reflects all light waves remaining "colorless." (Perhaps this is why black is a slimming color: because it doesn't eat!)

And what about us? How are we able to see color? Our eyes have specialized cells called *cones* that are able to differentiate which color is being reflected by the banana, grape, strawberry, or green apple. It's estimated that a single eye has six to seven million of these individual cones. Which begs the question: Who counted them all?

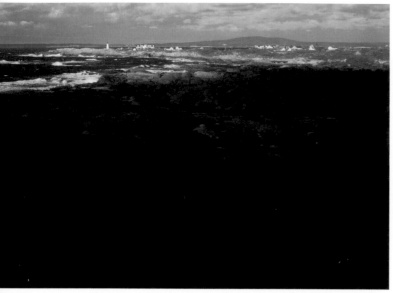

One morning I was sitting atop a small hill just south of Peggy's Cove in Nova Scotia; the sky overhead was billowing with white puffy clouds and large patches of blue sky. This is a favorite lighting condition for many landscape photographers because of the combination of light and shadows, and it's *the* favorite one for time-lapse photographers because of the changes from light to dark and back again.

Looking at these four examples, it is clear that as light moves across the landscape, color is revealed. Without light, objects are black. But with light, we begin to see what color light waves each object reflects. In this case, the landscape had an appetite for warm oranges and reds as well as greens and blues.

All: Nikon D800E, Nikkor 70–300mm lens, *f*/16 for 1/200 sec., ISO 200, tripod

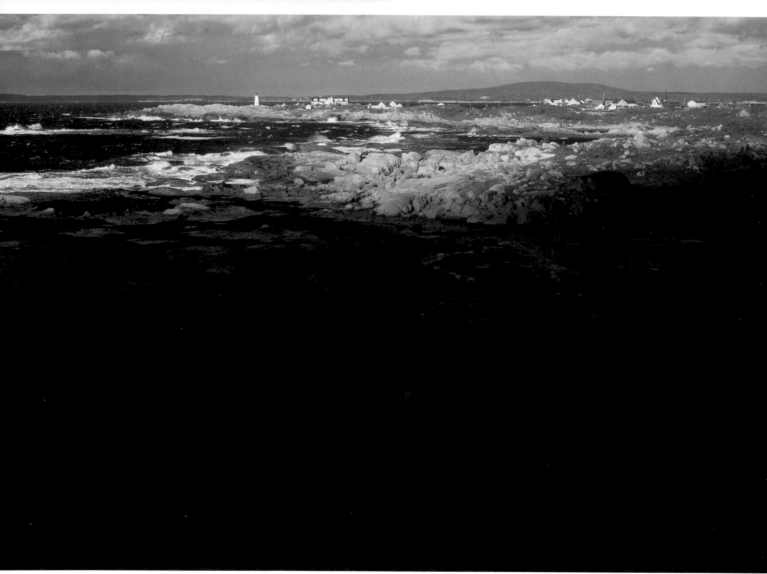

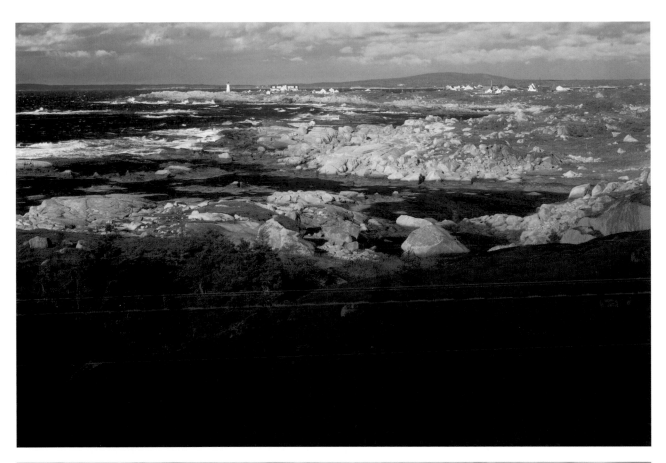

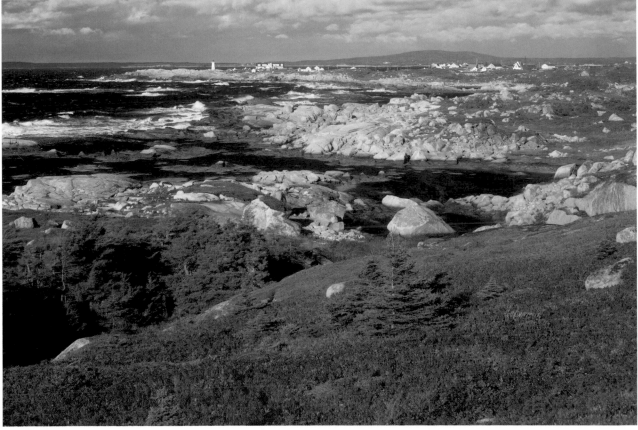

EXPOSURE AND COLOR

As some of you know, your camera's built-in light meter is responsible for telling you how to set a correct exposure for the light reflecting off any subject. It reads the reflected light and indicates what the correct exposure will be, combining aperture, shutter speed, and ISO—at least, it does so most of the time.

Your camera's light meter has been programmed to interpret *all* reflected light in the world as if it were *always* reflecting off of a neutral gray surface. Yes, that's right: a neutral gray surface. Your camera's light meter has been built to believe that the world is colorless. It never sees those passionate reds, cheerful yellows, or stable blues, not to mention black or white.

If we lived in the world of our light meter, we would all have gray skin, wear gray clothes, eat gray food, sit on gray furniture, and wake up under gray sheets to the sound of our gray alarm clock, after which we would get into our gray car and drive down the gray road to the gray hardware store, where we would easily find that gallon of gray paint to touch up the gray picket fence surrounding our gray home! Needless to say, we don't share the same vision as our camera's light meter; we live in a very colorful world, for better or worse. Yet unless we embrace the colorless world of the light meter, we will at times be sadly disappointed by colors in our exposures that are too dark, too bright, or just lifeless.

In fact, the reflected light in our world is not a level playing field, because not all light is reflected equally. For example, the light reflected off of snow or a bride's white gown is, at a minimum, twice as bright as gray. But when your light meter is presented with a composition that is largely white, it does the only thing it knows how to do: it turns all of that white into tones of gray. What the light meter is actually doing, in the absence of any intervention from you, is creating an image that is *under*exposed: "dark white," if you will—or, put another way, gray.

At the other extreme, the light reflected off of a black car or black Labrador dog is, at a minimum, twice as dark as gray. When your light meter is presented with a composition largely of black,

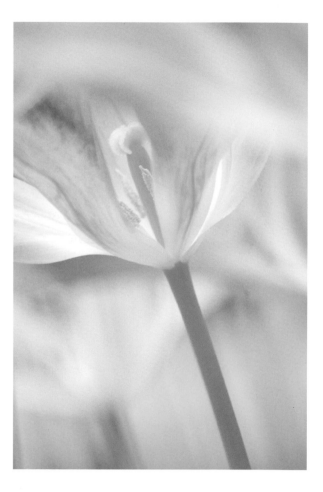

A flower feast awaits visitors to the windless greenhouse displays at the Keukenhof Gardens in Holland. But if you're not careful when exposing those bright yellow and white tulips, you'll go home with very dull images. Experience has taught me that overexposing light yellows and pinks by +1 will result in a correct exposure, rather than the darker tones that result from listening to the light meter.

Nikon D800E, Nikkor 70-300mm lens with 36mm extension tube, *f*/6.3 for 1/200 sec., ISO 200

it again does the only thing it knows how to do: it turns all of that black into tones of gray. This time—again, in the absence of any intervention from you—the light meter creates an image that is *over*exposed, making it "light black," or, yes, gray. The built-in light meters of all cameras today are based upon this simple law. No one is immune.

If you are looking for the math, here it comes. If you were to measure the amount of light reflected off of a neutral gray object, you would discover it to be 18 percent. Your camera's light meter sees the world as gray and, as such, assumes that every single object in the world reflects 18 percent of the light that hits it. But in fact, *white* snow reflects at least 36 percent of light, and a *black* Labrador dog only reflects about 9 percent. Now here is where you come in! Here is where you get to grab that light meter by the horns and show it who's boss.

From now on, when shooting white subjects, you will deliberately set at least +1 exposure. When shooting black or very dark subjects, you will deliberately set at least −1 exposure. That's right: although it sounds counterintuitive, you will allow the shutter to stay open at least one stop longer (or set the aperture one stop larger) when shooting white subjects to avoid the normal underexposed gray, dark-white color. And you will deliberately make the shutter speed one stop faster (or set the aperture one stop smaller) when shooting black or very dark subjects to avoid an overexposed gray, light-black color.

Are there other colors that need your special attention? You bet. If you are *mostly* filling your frame with crimson red, the deep purple of lavender flowers, or even royal navy blues, treat them like black: set your exposure to −1. If you are filling the frame with *mostly* bright yellows, light pinks, light oranges, or peach tones, treat them like white: set your exposure to +1. And what about all the other colors? Experience has taught me that if my frame is dominated by midtones of green, blue, or red, setting an exposure of −2/3rds seems to produce the best color of all.

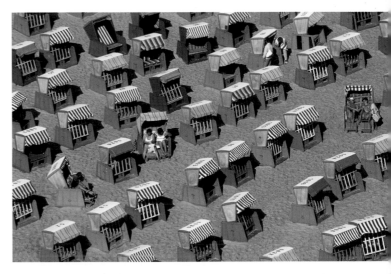

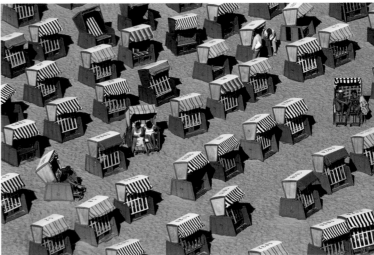

We see color, but your camera's light meter has been programmed to see the world as one big midtone of neutral gray. To illustrate this, I altered this color photo of beachgoers in Warnemünde, Germany, turning it into a simple black-and-white image. Our eye/brain of course sees the colorful image, but the camera's light meter "sees" the same scene as if everything were neutral gray. Since everything in this scene is, in fact, a midtone, the meter gets it right, correctly interpreting the colors as gray midtones reflecting 18 percent of the light. And, in fact, the meter gets it right for most scenes, recognizing that most colors reflect about 18 percent of the light and directing you to a correct exposure. Unfortunately, the world is not only made of midtones, confusing the light meter when it sees white and black. But not to worry: you will soon discover how easy it is to "un-confuse" the light meter.

Nikon D5, Nikkor 70–300mm lens, *f*/16 for 1/125 sec., ISO 100

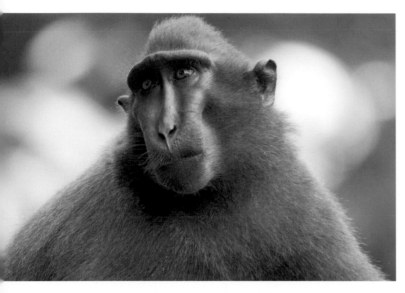

A black monkey at the Singapore Zoo is greeted by my camera's light meter with a degree of confusion. Because the light meter thinks everything in the world is gray, it directs me to adjust my aperture and shutter speed until the monkey looks, in fact, gray. And, as you can see in the first example, listening to the light meter's advice resulted in the promised gray monkey, which is in fact an overexposed *black* monkey. The light meter also overexposed the rich green tones of the background. Of course, I learned long ago not to listen to my light meter when shooting black subjects, and by resetting my camera to a –1 1/3 stop exposure, I captured the colors and hues I was after. —SUSANA

Left: Nikon D7100, Nikkor 200–500mm lens at 500mm, *f*/10 for 1/250 sec., ISO 1250; below: Nikon D7100, Nikkor 200–500mm lens at 500mm, *f*/10 for 1/640 sec., ISO 1250

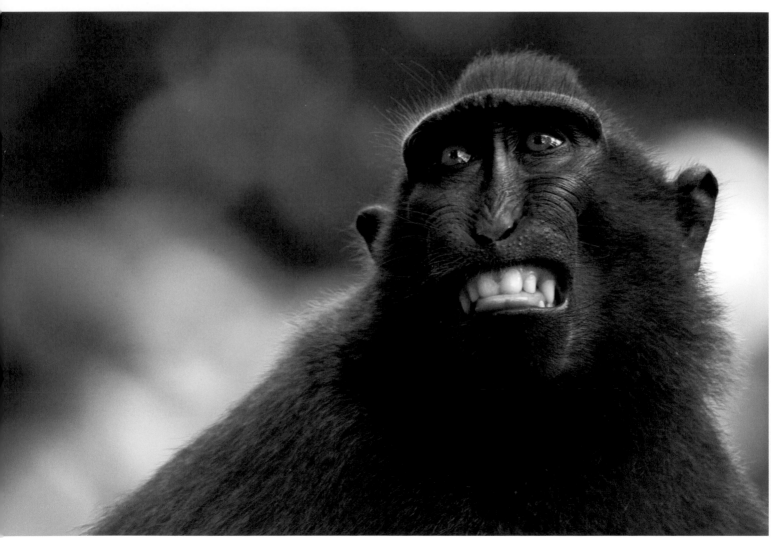

Just as with the color black, objects that are white will confuse your light meter. White subjects are often much brighter than neutral gray tones, so the light meter will direct you to underexpose your image to turn that white object gray. When I came upon this mostly white dog lying atop a white step against a white wall, I knew the light meter had met its match. In the first example, I simply followed the light meter's recommendation and, yep, I got my gray everything! The solution in such cases is to take charge and either increase the size of the aperture (i.e., go to a smaller number) or increase the number (for a smaller opening) or decrease the shutter speed at least one full stop. Here, I set an overexposure of +1 2/3 and recorded a much truer white.

Right: Nikon D800E, Nikkor 24–120mm lens, f/11 for 1/400 sec., ISO 400; below: Nikon D800E, Nikkor 24–120mm lens, f/11 for 1/125 sec., ISO 400

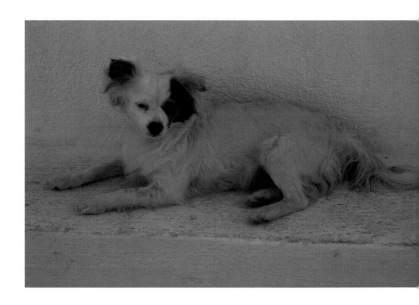

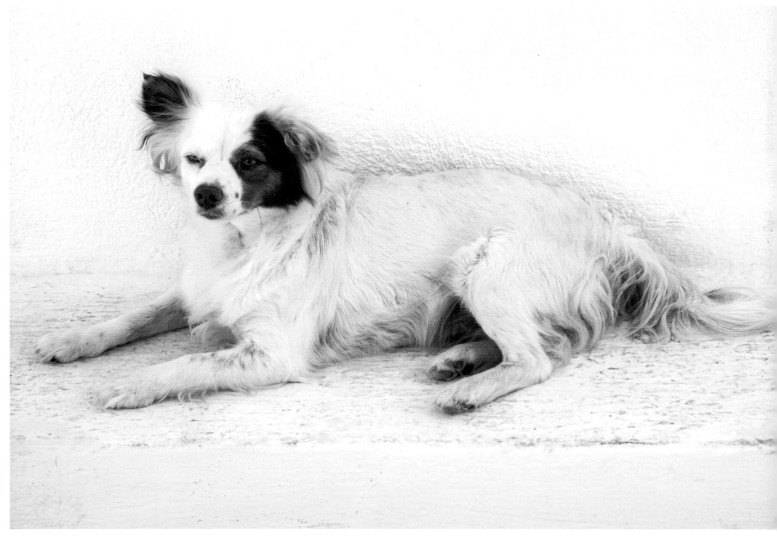

WHITE BALANCE AND COLOR TEMPERATURE

Are you confused about white balance? It's my opinion that, next to the histogram (a.k.a. the "hysteria-gram"), the white balance (WB) setting is one of the most overrated controls on the digital camera. I have seen online forums discussing white balance, and there are some very strong feelings about its importance. But, until someone can convince me otherwise, I will continue, for the most part, simply setting my white balance to Direct Sunlight (or "Sunny" on a Canon) and then leaving it alone.

As we discussed earlier in the section on Light and the Science of Color (page 12), the colors we see are actually "rejected" colors, those for which the object has no appetite. But guess what else? Each rejected color also has a *temperature*, often described as "cool" or "warm." Going back to our idea of the Rainbow Delivery food service, imagine that the food they deliver (the "light") was delivered as cold, cool, warm, or hot. The temperature of the food (the light) depended on which time of day it was delivered and under what weather conditions. Food delivered under clear, sunny skies was warmer than deliveries made under cloudy skies.

Color temperature is measured by what is called the *Kelvin scale*, which is nothing more than an extension of the Celsius scale. On any given day, the color temperature of the light that falls on our world is measured in degrees Kelvin (K), from roughly 2,000 K to 11,000 K. A color temperature of between 7,000 and 11,000 K is considered "cool" (bluer shades would fall in this range), a color temperature of between 2,000 and 4,000 K is considered "warm" (reds would fall in this range), and a color temperature of between 4,000 and 7,000 K is considered "daylight" (or the combination of red and blue).

Cool light is found on cloudy, rainy, foggy, or snowy days, or in areas of open shade on sunny days (the north side of your house or in the woods under the shade of the trees for example). The reason for this is that the moisture-laden clouds filter, or "eat," the warm light, and in the darkness of the shade, the contrast of that remaining blue light is made more apparent leaving behind the cooler light. Warm light is found on sunny days, beginning a bit before dawn and lasting for about two hours, and then beginning again about two hours before sunset and lasting for another twenty or thirty minutes after the sun has set. Warmer light is most noticeable in the morning and late afternoon because that's when the sun is farthest from Earth. The warmer red and orange rays of light have much longer visible spectra (longer "arms," if you will), and are able to reach Earth in greater quantities than blue and green.

During my last six years of using film, I made 90 percent of my images with Fuijchrome Velvia and Kodak's E100VS, both highly saturated color slide films. When shooting in overcast, rainy, snowy, foggy, or open-shade/sunny-day conditions, I often used my 81-A or 81-B warming filters. These would add red to the scene, in effect knocking down, if not out, the blue light. I prefer my images warm. One of the problems I had with digital photography in the beginning was its inability to produce in the raw file these same highly saturated colors—until I stumbled upon the Cloudy white balance setting, that is. (It would have also been possible to still use warming filters, of course, but this didn't occur to me at the time.) While using my Nikon D3X and my D300, the Cloudy setting successfully replicated the effect of using warming filters. When I moved on to my current camera, the Nikon D800E, however, which has a much "warmer" color processor, the Cloudy setting was just too warm. I now use the Direct Sunlight setting for almost everything. It's not too warm and not too cool, but, as Goldilocks

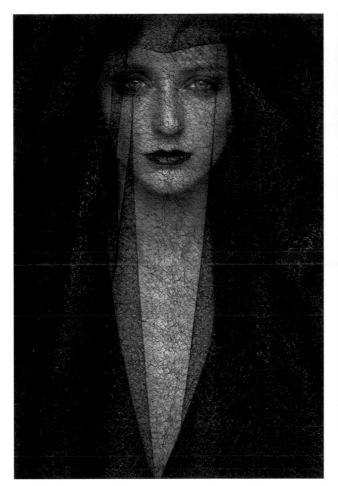

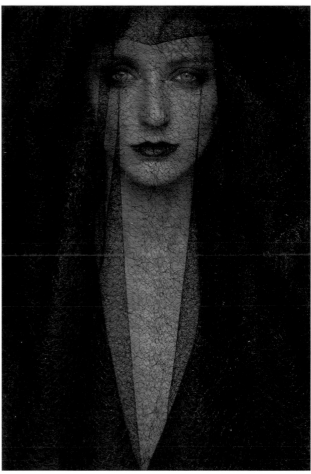

To shoot these images of the well-known Czech model Maja, I arranged black-netted material around her face and shoulders to create the effect of a woman in mourning and then placed her next to a large south-facing window. The only difference between the two photographs is the white balance setting. The first is set to Direct Sunlight, which renders a more natural, beige skin tone. The second, shot with a Cloudy WB, is noticeably warmer, suggesting a

slight suntan. In this instance, the Direct Sunlight WB more accurately captures Maja's actual skin tone. (If I'd wished to show Maja with a warmer skin tone, however, I could simply switch the WB to Cloudy.)

Nikon D810, Nikkor 24–120mm lens, *f*/11 for 1/125 sec., ISO 400

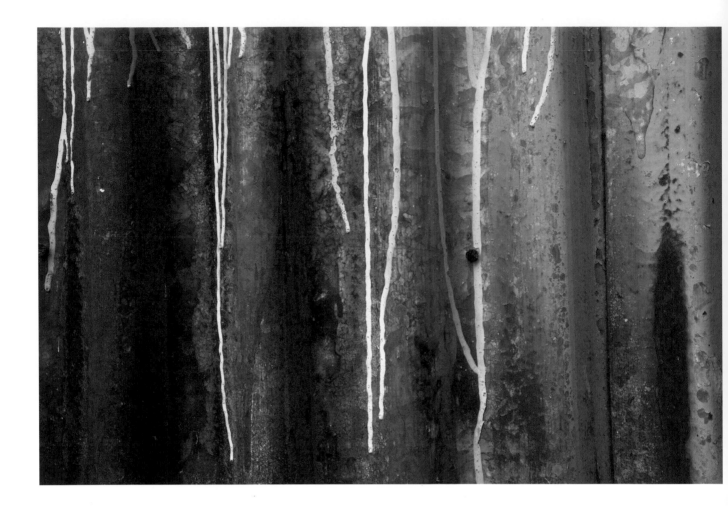

is fond of saying, "just right." My Direct Sunlight white balance setting seldom changes, whether I'm shooting on a sunny, cloudy, rainy, foggy, or snowy day.

In the spirit of knowing a little bit about everything, of course, I encourage you to spend time playing around with your white balance settings. When photographing a subject in open shade with a clear blue sky overhead, for example, try the Shade setting, which will substantially reduce if not eliminate much of the bluish cast always recorded in such situations. Experience manipulating your white balance will come in handy when you find yourself in tricky lighting situations, such as shooting indoors with both interior lighting and overhead skylights illuminating the room.

But experimentation aside, it is my recommendation to set your white balance to Direct Sunlight/Sunny or Cloudy for most outdoor shooting. Just please do not leave your camera on Auto WB. In fact, one of the aims of this book is to get you off of anything marked "A," including Auto-Focus, Auto-ISO, Auto-Exposure, and of course, Auto WB. When you have the occasional image that needs white balance adjusting, you can do it in postprocessing (assuming, of course, that you're shooting raw files—and if you're not shooting raw, you should be).

If you're shocked by my white balance choice, hear me out. I am, for the most part, a natural-light photographer, as probably are most of you reading this book. I seldom, if ever, shoot interiors. If I were shooting interiors that had a great deal of artificial light, then and only then would I shift my white balance to the appropriate setting (such as Tungsten/Incandescent for ordinary household

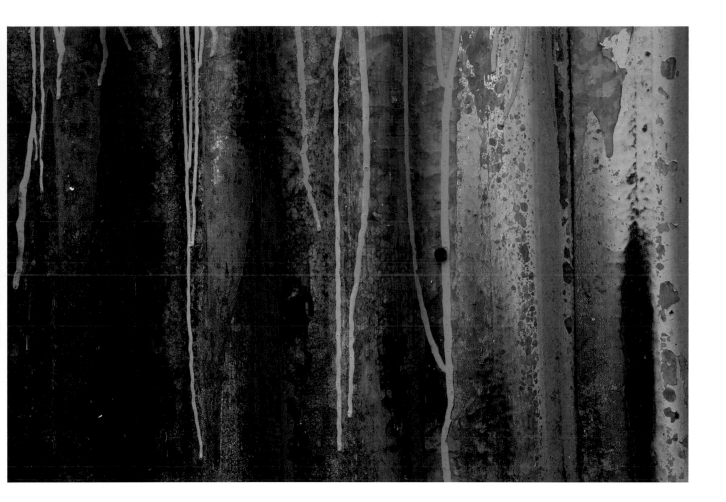

lighting, or Fluorescent for office lighting). The only other exceptions are when I use my Nikon SB-900 strobes to photograph objects against white backgrounds in my mini studio setup or when I'm doing commercial work and using strobes to light an interior. (In both of these situations, I usually end up using the Flash white balance setting.) I'm also a photographer who tends to shoot only during certain times of the day. On sunny days, I shoot in the early morning or from late afternoon to dusk. Midday light, between 11 a.m. and 3 p.m., is what I call "poolside light." Meaning, if there's a pool nearby, that's where you'll find me lounging—with a bit of sunblock, of course.

Note the warm and cold compositions of this corrugated metal wall in Jodhpur, India. Again, the only difference is a change in the white balance setting; the first image was shot in Shade WB and the second in Tungsten/Incandescent WB. Shade imparts a much warmer color cast than does Tungsten/Incandescent.

Nikon D800E, Nikkor 105mm micro lens, f/22 for 1/60 sec., 100 ISO

CAPTURING REALISTIC SKIN TONES

Is it possible to record perfect skin tones when shooting compositions of people?

Whether you're shooting candids or posing your subjects, there are any number of variables that can interfere with the "right" tone and color of a given subject's skin tones and clothing. The subject of photographing people is, of course, worthy of an entire book, but I would be remiss if I did not at least share four common mistakes that negatively impact your subject's skin color. In all of these scenarios, you run the risk of contaminating the subject's skin tone with foreign color, which in turn means that you will have to spend unnecessary time in postprocessing, cleaning up a mess that could have been avoided. So, here are four pitfalls to avoid.

1. *Using the "wrong" white balance setting.* It has been my experience that Auto white balance (WB) will almost always give your images a tinge more blue than you want. Granted, it's a personal choice, but I find warmer skin tones to be more inviting and prefer using Direct Sunlight WB (on Nikon) or Sunny WB (on Canon) most of the time. (For more about white balance, see page 22.)

2. *Shooting in the "wrong" kind of light.* While I prefer warmth in my images, there is a large divide between warm skin tones and those that look like sunbaked lobsters. When shooting posed subjects, look for locations that take the subject away from low-angled sunlight and avoid shooting in the very warm sidelight or frontlight of early morning and late afternoon.

3. *Not paying attention to light reflecting onto your subject's skin from an adjacent colored wall.* The easiest solution is, of course, to simply move your subject away from the colored wall, boat, or car. If that's not possible, you can often remove the unwanted color cast in postprocessing.

4. *Being fooled by the meter when shooting darker-skinned subjects.* As a general rule of thumb, set your exposure for –1 when shooting darker-skinned subjects. Remember, your meter wants you to make dark subjects gray. In order to do that, it will try to guide you toward overexposing the subject—usually by at least one stop. If you ignore the meter and set your exposure to –1 of whatever the light meter suggests, you will record a truer skin tone.

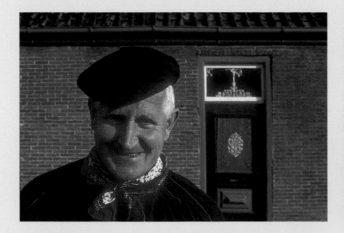
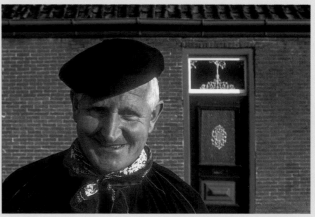

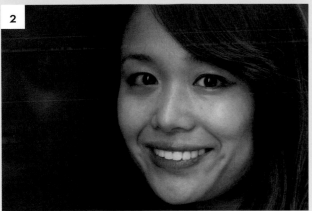

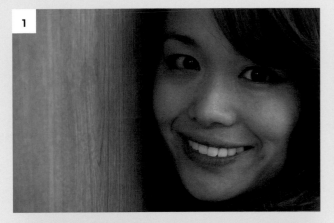

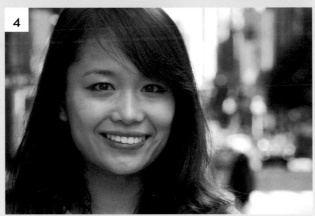

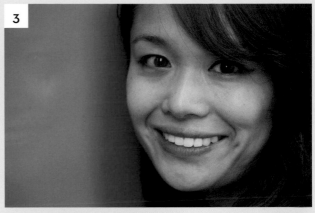

I have seen the problem of color contamination countless times in the classes I teach at my online school. To be clear, color contamination is not limited to portraits of family members, friends, or strangers, but it seems the most prevalent when these subjects are photographed.

Getting your subject to relax and simply smile is often the goal of many a simple portrait, and I fully understand why you might just say to your subject, "Go ahead and just lean up against that wall, cross your legs and arms, and just kick back and relax." Unless that wall you are using is white or a neutral gray or black, I would strongly advise against using it as a prop, because you will clearly get

some unwelcomed color bouncing from that wall onto your subject's skin and clothing. As is obvious in these three examples of my friend Aya, the red, orange, and blue wall have all cast their color onto her skin.

The solution, more often than not, is to shoot your portrait away from colored walls, as was the case in the fourth image of Aya, which I shot out in the open against the backdrop of early morning in New York City's Times Square.

Images 1 to 3: Nikon D7200, Nikkor 18–300mm lens at 260mm, f/7.1 for 1/200 sec, ISO 400; Image 4: Nikon D7200, Nikkor 18–300mm lens at 300mm f/6.3 for 1/320 sec, ISO 200

OPPOSITE: It was about twenty minutes before sunset and the light cast a very warm red-orange glow. For subjects who are fair-skinned, as here, that reddish tone can end up looking like a sunburn. I couldn't move the subject to a different time or location since I wanted to incorporate his farmhouse in the background, so I set my white balance to Direct Sunlight and surrendered to the warmer skin tones,

removing them later in postprocessing (by calling upon Photoshop's Color Balance tool and adjusting the cyan/red sliders).

Both images: Nikon D3S, Nikkor 24–85mm lens, f/8 for 1/200 sec., ISO 100, Direct Sunlight WB

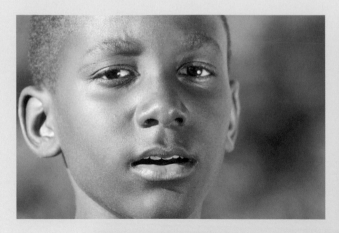
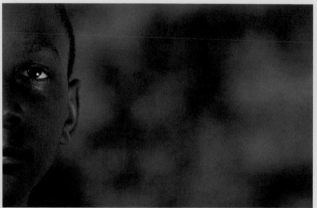

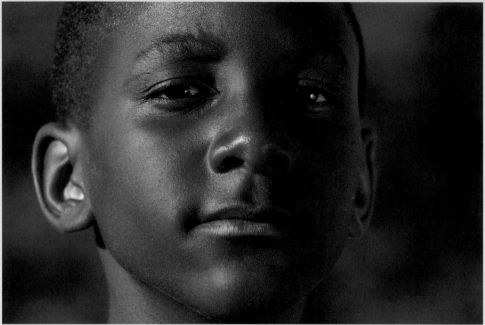

More often than not, without some intervention from you the photographer, you will record an overexposure of dark-skinned subjects, as is evident in the first image of this young boy.

The reason is simple; dark-skinned subjects have a reflected value lower than 18 percent and the light in turn suggests that you set an exposure that will render the subject "lighter in color," in effect make them gray or, in other words, making the subject over-exposed. The fact is, dark-skinned subjects must be deliberately underexposed if you wish to record the correct exposure.

Yes, I know it sounds counterintuitive, but trust me, it works.

There were actually several options I had to choose from when metering for a correct exposure of this young boy. I could have just as easily set my exposure at -1 as I framed up his face and felt confident that I would record a correct exposure, or as I have done countless times before when presented with the color green, I could take my meter reading from the green background in this scene and set an exposure at -2/3 for the midtone green. Either option would have resulting in the same outcome, a correct exposure.

All images: Nikon D3X, Nikkor 70–300mm lens at 240mm, *f*/7.1 for 1/800 sec, ISO 200.

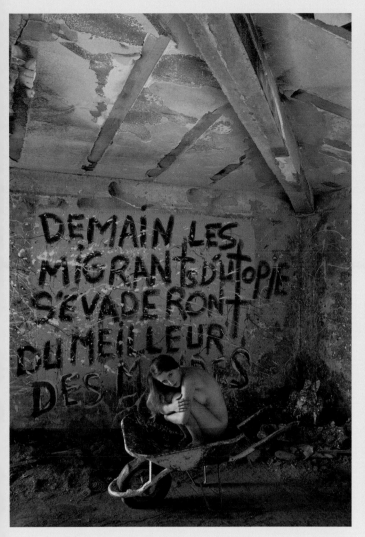
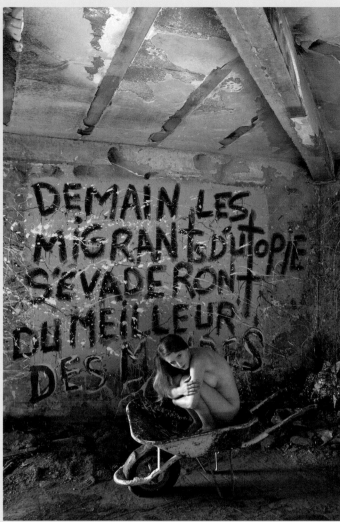

The only difference between these two photographs is the white balance (WB) setting. The first image was taken using Auto WB; the second using Direct Sunlight WB (or Sunny on Canon cameras). Notice the much cooler skin tones in the first image versus the warmer tones in the second.

Right: Nikon D810, Nikkor 24–120mm lens, f/11 for 1/60 sec., ISO 200, Auto WB; left: Nikon D810, Nikkor 24–120mm lens, f/11 for 1/60 sec., ISO 200, Direct Sunlight WB

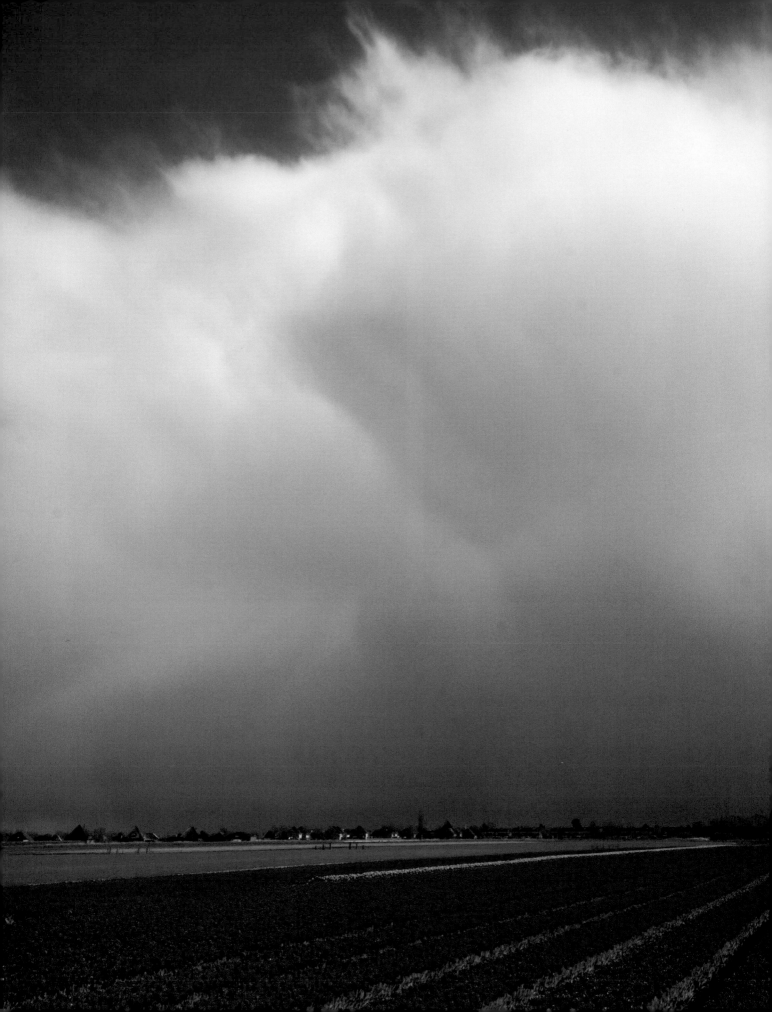

COLOR AND COMPOSITION

USING COLOR FOR HIGH-IMPACT IMAGES

Is it the content or the arrangement of that content that catches our attention when viewing a photograph? Some photographs do succeed in grabbing our attention solely based on content, but if you intend to *hold* on to your audience's attention, you need to pay close attention to the final arrangement before you press the shutter.

Granted, color is just a single note in the overall music of any composition, but it is often the loudest, or lead, note, if not the one that sets the overall melody. Your choice in color is your unique compositional responsibility, the one creative tool that is constantly under your control (or perhaps out of control?) in your overall vision.

All photographs are comprised of various elements of design—line, shape, form, texture, and pattern—but our perception of these design elements is affected in large measure by the *color* of that line, form, or texture. For example, thin lines, long lines, short lines, horizontal lines, jagged lines, and curved lines will convey entirely different "visual weights" depending on their color. The visual weight of blue or green, for example, is perceived to be much lighter than that of red or orange. Warmer colors are felt as being fuller, denser, and thus more important. And no one color is more important in its ability to get one's attention than the color red, though I discovered long ago that red is not the only way to create images with high color impact. Just about any combination of complementary or contrasting colors will turn up the volume of your photo.

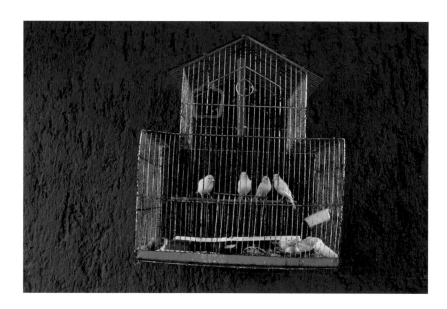

One late afternoon, while walking through a neighborhood near downtown Guadalajara, Mexico, I heard chirps and looked to my left to see four separate birdcages suspended on a blue garage wall. The only thing that stood between me and getting the shot was a secured gate. To my amazement, the owner of the house walked up the same sidewalk right behind me, and yep, he opened the gate and invited me inside, where I shot a number of compositions. The dominant blue and yellow accent combine to make an image with great contrast.

Nikon D800, Nikkor 24–120mm lens at 35mm, *f*/14 for 1/160 sec., ISO 640

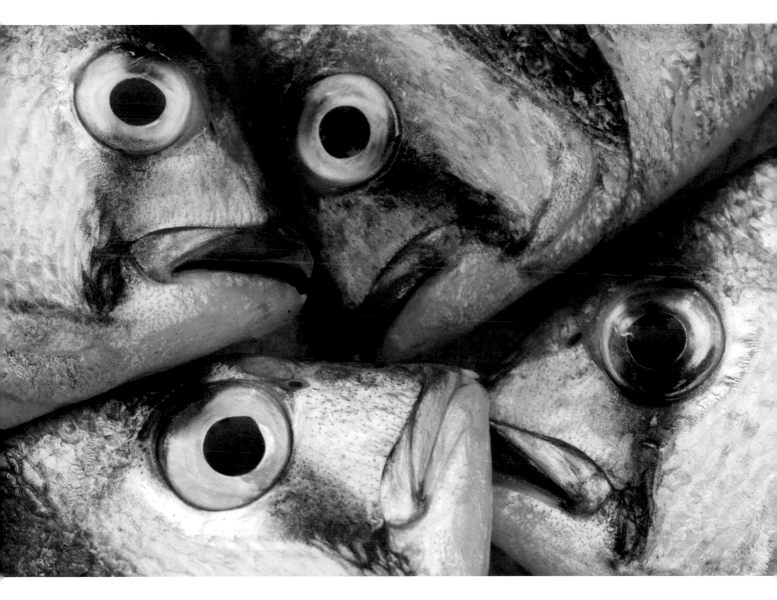

Line and color are big parts of my compositional style, and this "portrait" of four fish, taken at the Dubai Fish Market, shows ample use of both. I could have composed a very simple dead fish, but my intent was to engage and hold on to my audience, and this is where color comes into play. Moving in close allowed me to include four distinct triangle-like fish-head shapes as well as a broken parallelogram created by the dark lines running down from the eyes. The lines create a harmonious sense of movement, and the yellow makes it a somehow "cheerful" composition, despite the fact that we are looking at dead fish.

Nikon D800E, Nikkor 24–120mm lens at 120mm, *f*/13 for 1/100 sec., ISO 200, tripod, Direct Sunlight WB

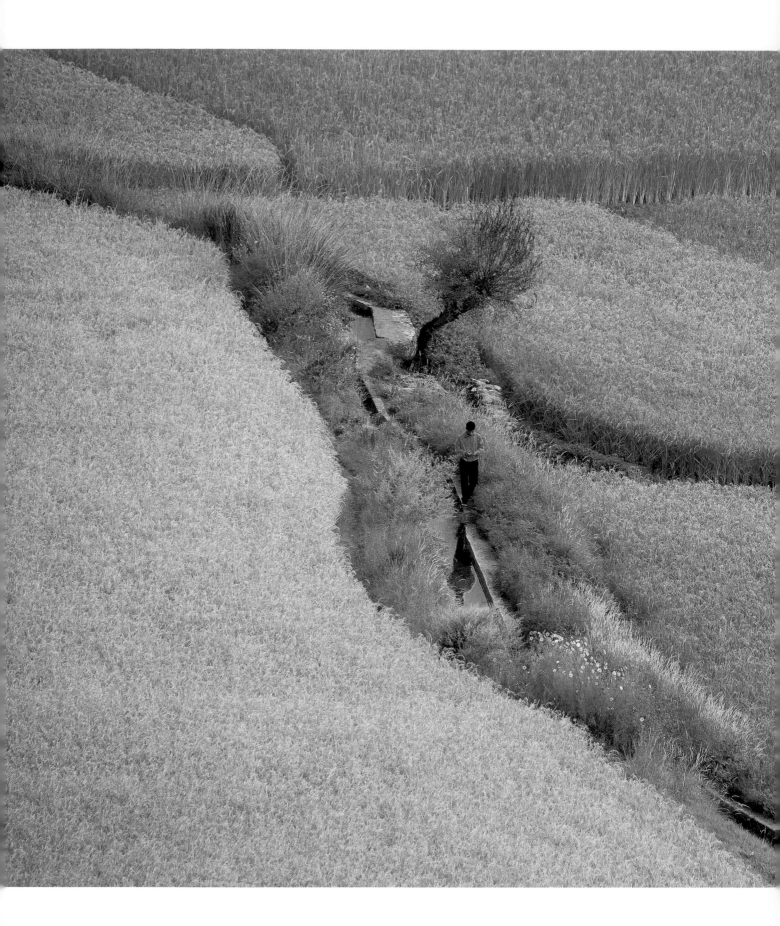

From my hilltop hotel in Paro, Bhutan, I was afforded a fantastic view of the surrounding mountains and the many hectares of rice fields below. In the distance, my eyes caught sight of several locals "floating" across the fields. It was only as they got nearer that I could see a small concrete path under their feet. Within minutes, the rice fields came alive as more and more people began entering from various points, all alighting on these almost hidden and very narrow concrete trails. I was witnessing, from my somewhat bird's-eye view, the "morning commute" of Paro, Bhutan!

As luck would have it, I didn't have to wait long for the lone commuter wearing a red sweater. I focused solely on the figure in red using "single spot" focus, the red providing just enough contrast to the surrounding shades of green to make it clear that he is indeed the subject.

Nikon D7200, Nikkor 18–300mm lens at 300mm (with an effective focal length 450mm), *f*/13 for 1/200 sec., ISO 640

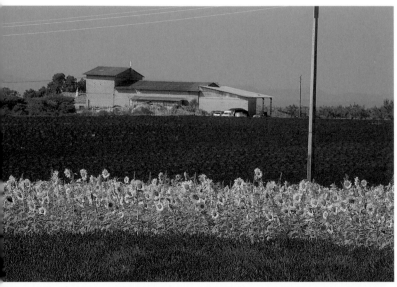

One of the greatest hindrances to a successful composition is an unclear subject. This usually happens when there is too much clutter around the intended subject, whether because you didn't have the right lens or you failed to zoom in with your feet (meaning, you lacked the desire to walk closer to the subject). As you look at this first example here, you can see the clutter immediately. Instead of being treated to the wonderful "music" of a single radio station (in this case, a purple and yellow color block), we instead hear several stations at once, with a lot of interference. I needed to do some fine tuning. In the next example, I eliminated the clutter to highlight a vivid color block. Zooming in closer is all it took.

Nikon D800E, Nikkor 70–300 lens at 270mm, *f*/32 for 1/60 sec., ISO 200

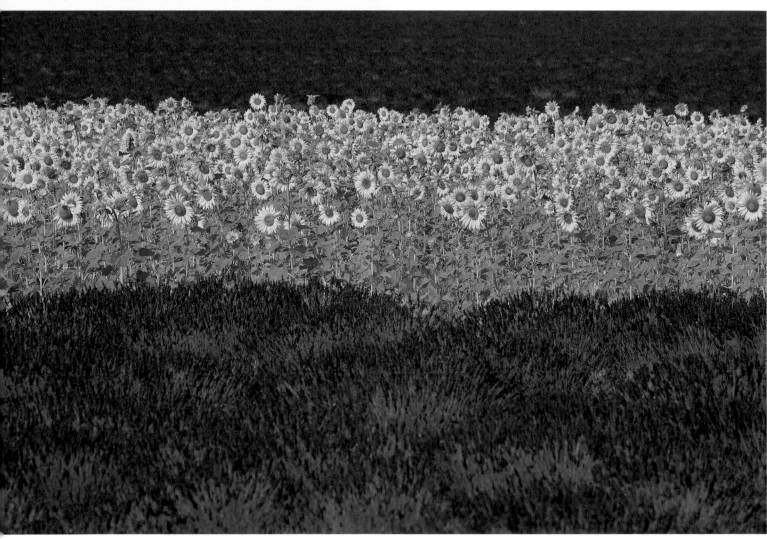

THE COLOR WHEEL

You may not realize it, but your whole life has been, to some degree, impacted by color. From the clothes you buy to the advertisements and products you respond to, color impacts our decision-making process, our appetite, our fashion sense, and even our sense of smell. I am firmly convinced that most photographers do not understand the importance of color and its role not only in conveying mood and emotion but in basic composition.

The first step to understanding basic color theory—and how various colors relate to one another—is to spend some time with a color wheel (below). Much like the steering wheel of a car, the color wheel can direct you toward

countless successful adventures, but if you don't pay close attention, you can just as easily experience costly accidents.

The color wheel is an ordered arrangement of twelve colors that helps show their relationships to one another. It is based around the three *primary* colors: red, blue, and yellow. When these colors are mixed, we create *secondary* colors: green (blue mixed with yellow), violet (red mixed with blue), and orange (red mixed with yellow). Mixing secondary colors then leads to *tertiary* colors, such as red-violet and blue-green.

Pairs of colors that fall opposite each other on the wheel—such as orange and blue—are called

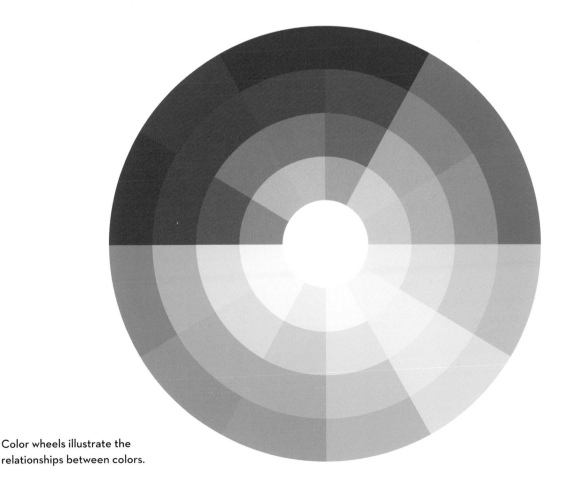

Color wheels illustrate the relationships between colors.

complementary colors. When placed side by side, these pairs complement and intensify each other. Groups of three colors next to each other—such as blue, blue-green, and green—are called *analogous* colors, which tend to be quieter combinations. Also, each primary color falls opposite a secondary color, and each secondary color falls somewhere between the two primary colors from which it is made. The relationships go on and on. Studying the color wheel can help you get a better feel for colors and how they affect one another.

In practice, however, nothing beats actually going out into nature or onto the city streets, where you can find ample evidence of color harmony and color contrast. With a copy of this color wheel in your bag, look for compositions that showcase *only* complementary colors (meaning, any two colors directly opposite each other on the color wheel, such as orange and blue). When you're finished, look for compositions of *analogous* colors (three colors found side by side on the color wheel, such as blue-violet, violet, and red-violet). The purpose of this exercise is to expand your vision as well as your awareness of all the color that really is everywhere.

Triadic colors also result in high-contrast images. Triads are composed of any three colors that are equally apart on the color wheel, the most obvious example being red, yellow, and blue. But a word of caution: it is best to let one of the three triadic colors dominate, with the other two as mere accents. When triadic colors are composed in equal measure, it can be like listening to the screams of hungry triplets: not a fun experience.

The colors on the color wheel are also referred to as *hues*. Red is a hue, as is blue-violet, yellow-orange,

and so on. But what about white and black, which aren't on the color wheel? This is where *tints*, *tones*, and *shades* come in. If you mix *white* with any hue on the color wheel, you are *tinting* it. Tints are also referred to as *pastels*; they are lighter, less intense, and less saturated than hues. Some say they feel calmer and more subdued. If, on the other hand, you mix *black* with any hue, you are *shading* it. Shades are richer, darker, and more intense than hues. And, lastly, a *tone* is created when you add *both* white and black (in effect, gray) to a hue. Depending on the ratio of white and black added, a tone can be lighter or darker than the original hue, but is always less saturated and intense.

If you want to lighten a hue, you simply add white to tint it. If you want to darken a hue, you shade it by adding black. And if you merely want to capture the correct tone of a subject, you add an equal measure of black and white (or gray). Any of these changes can be applied easily when using paint, but how do you do you apply a tint, tone, or shade to a given hue photographically? With the aid of Photoshop?

Certainly Photoshop can come in handy, but photographers were manipulating color long before Photoshop, so how did they do it? With a combination of exposure adjustments and shooting under various temperatures of light. Back in the days of film, it was common to *tint* a hue by overexposing it by a stop or two, akin to adding white to it. Similarly, we *shaded* hues by underexposing them by a stop or two, akin to adding black to them. Not much has changed today: overexposure is still like adding white; underexposure is still like adding black.

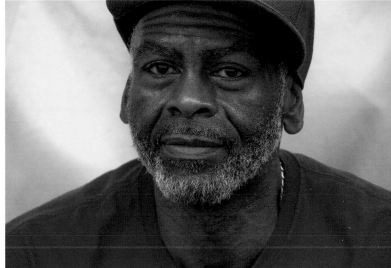

We were lucky to meet Dale Seth sitting outside his apartment in Cambridge, Maryland, dressed in a red shirt and blue cap—and luckier still to have a student's bright yellow raincoat on hand to create a "perfect storm" of triadic color. Does it scream too much? That opinion is yours, but one thing is certain: this is a colorful portrait and a simple exercise you can easily re-create with a friend, spouse, or neighbor. You might also want to try this revealing exercise in open shade or on an overcast day, when the colors will be more vivid and closer to their true tone and hue.

Nikon D7200, Nikkor 18–300mm lens, *f*/7.1 for 1/160 sec., ISO 200, Direct Sunlight WB

ADDITIVE VERSUS SUBTRACTIVE COLORS

The primary colors that I refer to in the text here—red, blue, and yellow—are also known as *subtractive* primary colors. From them, we get the subtractive secondary colors—violet, orange, and green. The subtractive color system involves colorants and reflected light. It uses pigments applied to a surface to *subtract* portions of the white light illuminating that surface and, in this way, produces colors. Combining the subtractive primary colors in equal parts produces the appearance of black. Color painting, color photography, and all color printing processes use subtractive color.

However, there is also another set of primaries, called *additive* primary colors, which are red, green, and blue. From these we get additive secondary colors: cyan, magenta, and yellow. Additive color involves light emitted from a source *before* it is reflected by an object. It starts with darkness and adds red, green, and blue light together to produce other colors. Combined in equal parts, additive primary colors produce the appearance of white. Television screens, computer monitors, digital and video cameras, and flatbed and drum scanners all use the additive color system.

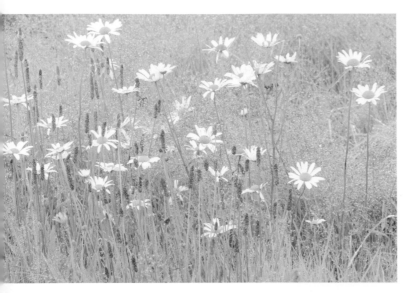

A wildflower meadow, full of morning dew, is still another reason why you might want to consider getting up early in the morning, not to mention the peaceful silence that exists along with the occasional and welcomed interruptions of the music emanating from any birds in the area.

As you look at these three images it is obvious that one image is lighter than the other two and that one is darker than the other two. I play with this idea of tinting more often than not when I want to record an exposure that is bit "lighter" in its visual weight. But if I want to record a "heavier" exposure, then shading is the way to go.

As I mentioned a moment ago, tinting was done in the days of film by simply overexposing the image by one, sometimes two stops, (i.e., +1 or +2) and shading was done by underexposing the image by one, sometimes two, stops (i.e., -1 or -2). Despite the digital age most of us now embrace, tinting and shading can still both be done, in camera, by the same overexposure or underexposure of the image, but for many, tinting and shading are both being experimented with in postprocessing when one has a more exacting control over how much or how little tinting or shading one wishes to add. The choice of when to tint or shade is of course yours, but it is something that is worth considering, especially when you feel the image is missing "that something." Maybe, it needs a little bit of tinting or shading!

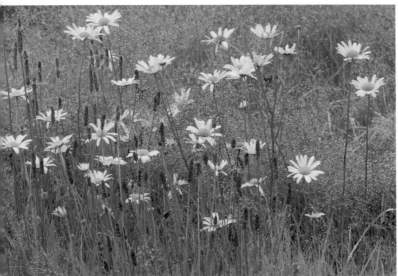

Top: Nikon D810, Nikkor 24-120mm lens at 120mm, *f*/13 for 1/100 sec., ISO 320; middle: Nikon D810, Nikkor 24-120mm at 120mm, *f*/13 for 1/200 sec., ISO 320; bottom: Nikon D810, Nikkor 24-120mm at 120mm, *f*/13 for 1/400 sec., ISO 320

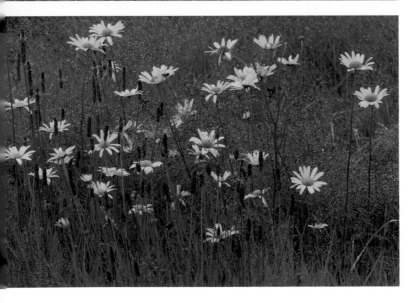

OPPOSITE: While in Kuwait City, Kuwait, in February 2016, I took this portrait of my taxi driver after our forty-five-minute chat while driving from the airport to my hotel. I had him pose just outside the hotel near the back of his taxi, and as I took a few quick exposures, I realized that the composition looked familiar. But from where? It was only when pulling images from my files for this book that the mystery was solved. Just four months earlier, while visiting my daughter at the University of Guadalajara, I had been out walking the streets on a lazy Sunday afternoon when I came upon an orange painted wall with two green Ficus benjamina trees growing in front of it. Orange and green are not complementary colors, but in both images, the orange of the shirt and wall are very much at home with the green of the bushes and trees.

Opposite, left: Nikon D810, Nikkor 24–120mm lens at 120mm, *f*/5.6 for 1/1250 sec., ISO 100; opposite, right: Nikon D810, Nikkor 24–120mm lens, *f*/16 for 1/100 sec., ISO 400

COMPLEMENTARY COLORS

Are you interested in creating compositions with colors that leap off the page? Then consider compositions comprising primarily complementary colors.

Complementary colors, like many happy couples, fulfill the saying, "opposites attract." What makes complementary colors opposite is that they do not contain any of the other color in them. Red and green are complementary colors; red contains no green in it, and vice versa. Blue and orange are also complementary colors; no blue is found in orange, and vice versa. The same is true of violet and yellow.

And just as with couples whose personalities contrast with and complement each other, the contrast and visual tension between complementary colors are what create interest and make both colors stand out. This is particularly true in images limited to two colors. Contrary to what you might expect, a larger area of one color is often less effective as the lead than as the supporting cast to the real star: the little yet very loud voice of the contrasting color.

Unfortunately, experience has taught me that compositions of vibrant complementary colors are seldom found on most city streets, short of a few locations in India and the island of Burano, Italy. When you are shooting a subject fully under your control, on the other hand, the opportunities to combine colors in varied combinations are unlimited.

What kinds of photo opportunities allow you complete control? Any time you are setting up a shot, from a simple portrait of a friend to a still life on your kitchen counter. At these times, you can use props and wardrobe to bring your composition to vibrantly colorful life. If a color punch is what you are looking for, this is the time to make your wishes known—such as by asking your subject to wear red when you're planning to photograph her in front of green leafy trees.

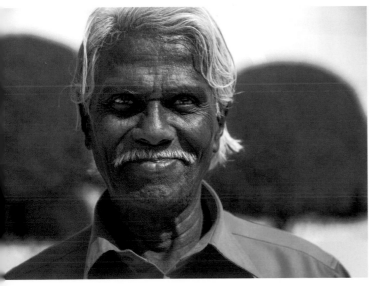

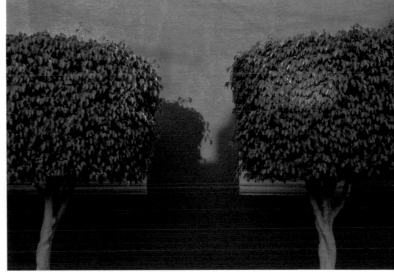

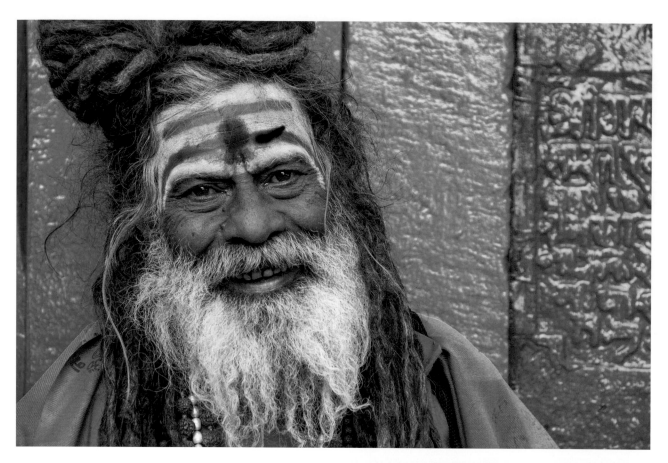

I met this *sadhu* (holy man) in Varanasi, India, very near the area where daily cremations of the dead take place along the banks of the Ganges River. Fortunately for me, a blue wall was very near and I was quick to have him sit down on an empty wooden cart that was parked up in front of it. The contrast of the blue wall with his orange robe makes a very strong color portrait due to the complementary nature of blue and orange.

Nikon D810, Nikkor 24mm–120mm lens at 120mm, *f*/5.6 for 1/320 sec., ISO 200

A freshly painted red bridge at the Singapore Bird and Butterfly Sanctuary served as a perfect backdrop for a freshly fallen green leaf. Visual tension between the red and green complementary colors adds intensity to the image, making both colors stand out. —SUSANA

Nikon D710, Nikkor 18–300mm lens at 58mm, *f*/5.6 for 1/80 sec., ISO 640

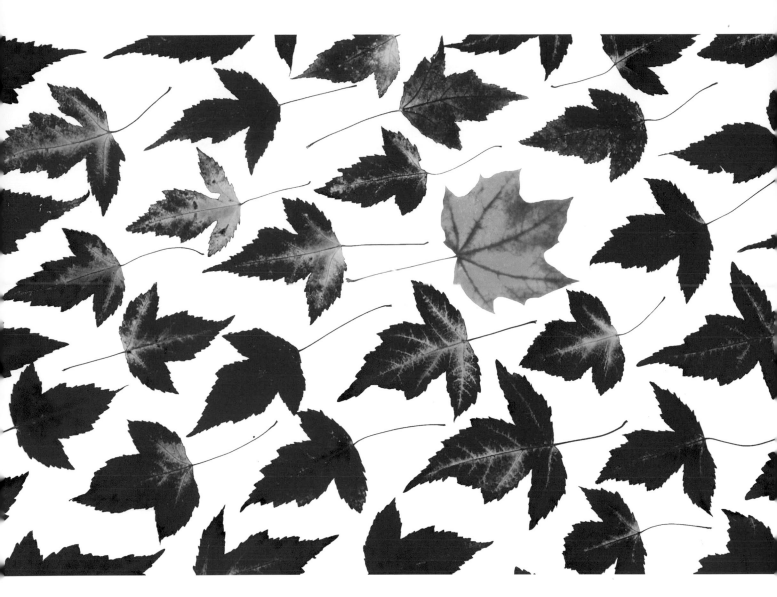

I lived in Chicago for five years, and by my second winter, I was well prepared for the daily onslaught of below-freezing temperatures that lasts for three to four months. Knowing that I would be spending a great deal of time indoors, I had gathered autumn leaves in September and October, pressing them between the pages of books with the intent of photographing them in January. The result is clearly an image about the complementary colors red and green. To

make this shot, I placed the leaves on a piece of frosted Plexiglas, lit from behind with one White Lightning Strobe and from above with another, creating pure white light from above and behind and resulting in an evenly lit subject.

Nikon D300S, Nikkor 24-85mm lens, *f*/13 for 1/200 sec., ISO 200

I purposely arrived at this field of purple flowers early in the morning, expecting to find a yellow swallowtail or two. As luck would have it, some butterflies soon came along searching for nectar. They were moving a bit slowly at that hour, allowing me ample to time to frame, focus, expose, and shoot. This photo is first and foremost a powerful image of the complementary colors yellow and purple.

Nikon D800E, Micro-Nikkor 105mm lens, *f*/11 for 1/160 sec., ISO 400

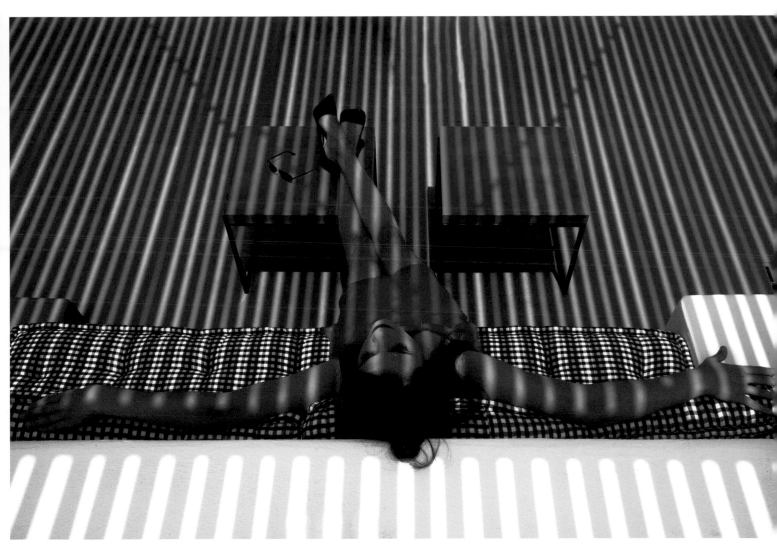

During a break while on the island of Santorini, Greece, I discovered a small art gallery that was beautifully lit with stripes of light and shadow from an overhanging slatted roof. The next day, I returned to the art gallery with a model in a bright orange dress and, as you can see, got my shot. Contrast this with the first photograph of me sitting on the same chair. The dark blue shirt I'm wearing absorbs the shadows; there is no contrast to separate the light and dark stripes. I mention this as an important reminder to make certain the wardrobe you suggest to your model complements the overall location and composition.

Both images: Nikon D800E, Nikkor 24–120mm lens, ƒ/22 for 1/100 sec., ISO 200

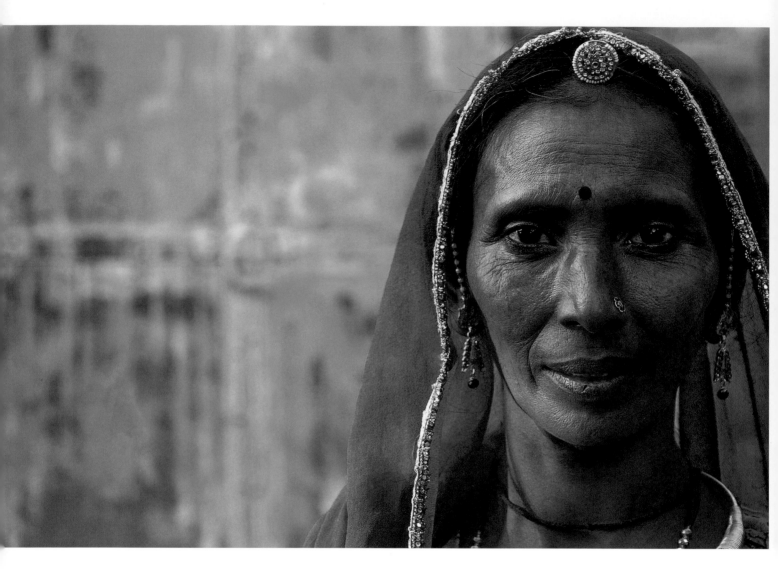

While in Jodhpur in the state of Rajasthan, in northern India, we visited an antique furniture restoration factory. The vast quantity of furniture was impressive, yet photographically I was more inclined to use the antiques as props and allow one of the colorfully clad cleaning ladies just finishing their shift to take the lead role—a role shared, that is, with the dappled light of a setting sun to the subject's left. The stellar lighting condition enhanced the colors and cast a spectacular glow over the entire portrait. Here again we see how two complementary colors combine to create great impact—in this case, the emerald green and pink accentuating the subject's "queenly" appearance. —SUSANA

Nikon D7200, Nikkor 24–120mm lens at 120mm, *f*/6.3 for 1/400 sec., ISO 200

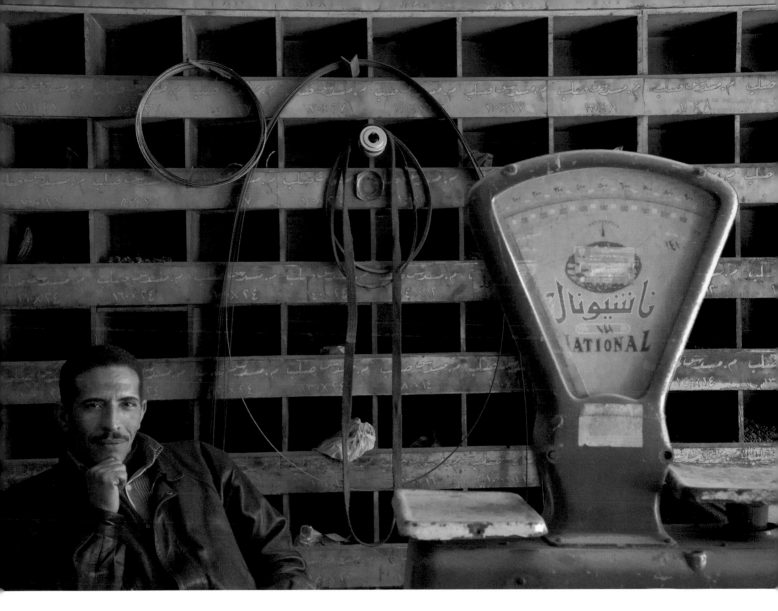

In Cairo, I walked into a parts store where this young Egyptian man was sitting at his desk. Also on that desk was a beautiful old red scale. The man invited me to join him for a cup of tea, and as we drank, we had a lively discussion of American foreign policy. Following our conversation, I asked if I could photograph him sitting at his desk against the background of green bins. While framing him against the bins, I found myself struggling with where exactly to include the red scale, which, given its size and color, could easily become the dominant subject. In this case, however, the scale serves as an anchor, a silent bystander. You cannot help but make eye contact with the man as he stares back at you, diminishing the visual weight and thus importance of the scale. (If the man had been looking at the scale instead, you would as well, making it the subject.) I love the contrasting green and red, as well as the soft sidelight coming in through a large open door.

Nikon D800E, Nikkor 24–120mm lens at 50mm, *f*/22 for 1/80 sec., ISO 400

ANALOGOUS COLORS

We have all heard the expression "The apple doesn't fall far from the tree" to describe a personality trait or behavior inherited from a parent or close relative. Analogous colors are very much like those apples, each member sharing many qualities with its "parents" on either side.

Analogous colors are groups of three colors next to each other on the color wheel, such as red, red-orange, and orange. Analogous colors are not known for their stark contrast. In fact, they are called upon for their *lack* of contrast and vibrancy.

Some argue that analogous colors are almost monochromatic, yet the subtle difference in color and tone can add a welcome quiet quality. If you are familiar with the work of Monet and Degas, both frequent users of analogous colors, you're aware of how serene and pleasing they can be.

For a simple yet memorable portrait, try having your subject wear a blue shirt while posed against a background of midtone green. The quiet of this simple color combination speaks loudly as it allows all of the attention to be on the subject.

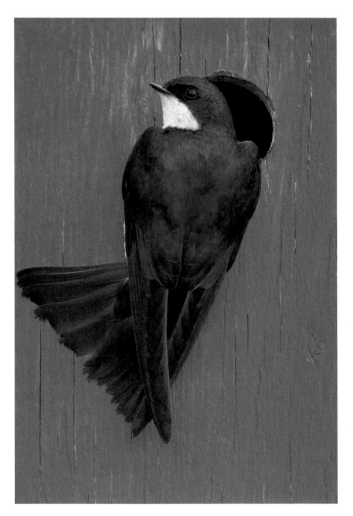

I am not a wildlife photographer, but if wildlife wants to come to me, I'll certainly photograph it. This was one of those rare times when it all came together. A purple martin flew up to its birdhouse, its mouth full of food (time to feed the kids!). Luckily, I happened to have my Nikon D810 with a Nikkor 200–500mm lens. As the purple martin held tight to the birdhouse, I had time to set up and shoot. The resulting image is first and foremost about analogous colors: in this case, the deep blue of the bird against the creamy blue-green of the birdhouse.

Nikon D810, Nikkor 200–500mm lens, *f*/13 for 1/400 sec., ISO 1600

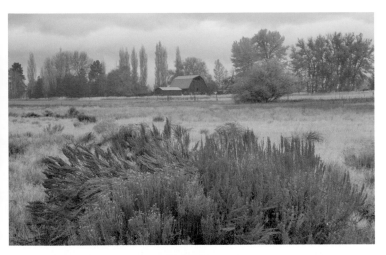

Just outside the small town of Sisters, Oregon, shortly after sunrise, I came upon this quiet farm scene and was immediately struck by the effect of the very soft light on the warm, earthy tones. The red barn surrounded by hints of red-orange and orange convey a quiet, almost monochromatic tone. Monet might have enjoyed painting a scene such as this, as it would have spoken to his love of analogous colors.

Nikon D7200, Nikkor 18–300mm lens at 50mm, *f*/22 for 1/30 sec., ISO 100

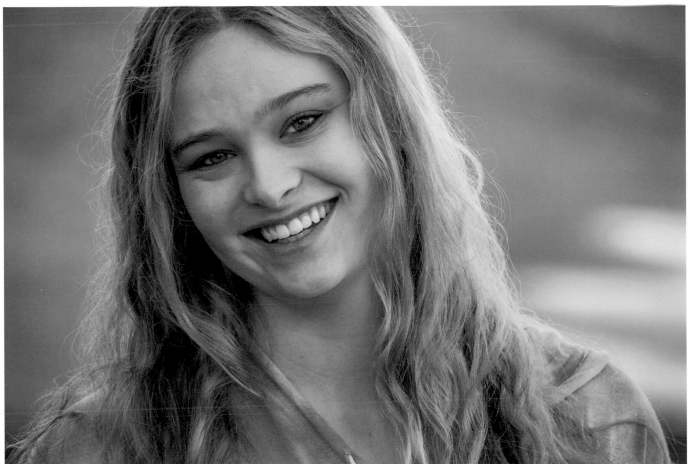

Analogous colors are once again present here, and not surprisingly, the color combination of light blue, green, and light green is extremely soothing to the eye.

A simple composition with an out-of-focus green background can easily be repeated at any number of local parks or, as in this case, against the backdrop of a very green golf course. Because green is such a youthful color, a color of hope and faith, it is a welcomed color as it celebrates the perpetual newness of life.

Nikon D7200, NIkkor 18–300mm lens at 300mm, *f*/7.1 for 1/400 sec., ISO 200

MONOCHROMATIC COLORS

Unlike complementary and analogous compositions, *monochromatic* compositions are primarily comprised of shades and tints of a single color. I have taught hundreds of students over the years, but rarely have I seen any of them produce a monochromatic image. Perhaps they shared the sentiment of one student who compared monochromatic compositions to listening to your favorite music through a cheap, single speaker. Why do that when you can listen to the same music in stereo? Obviously, I disagree. I feel quite strongly that monochromatic compositions are not only powerful but fairly easy to compose. Simply fill up the frame with all that color, and you're done.

Do I favor one color over another when thinking about monochromatic compositions? Not deliberately, but I do find that I am drawn to warmer colors, such as orange and red. These colors are anything but dull and lifeless. Granted, monochromatic compositions showcasing red run the risk of being overstimulating. But in my view, I'd rather lose my audience with an overly charged image than sedate them with a somber, melancholy image of blue or green.

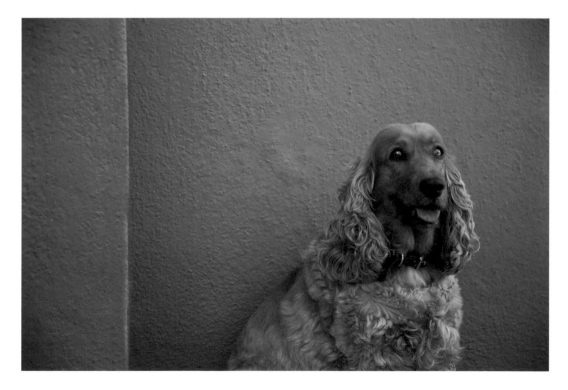

Opportunities to stumble across monochromatic compositions can be far and few between, which may help explain why so few photographers make them. But if you seek out colorful locations, such as the island of Burano, Italy, your odds increase substantially. It was here where I came upon this orange cocker spaniel sitting against an equally orange wall. Other than the warm red collar, this image is all about varying shades and tones of orange.

Nikon D800E, Nikkor 24–120mm lens at 105mm, *f*/11 for 1/160 sec., ISO 400

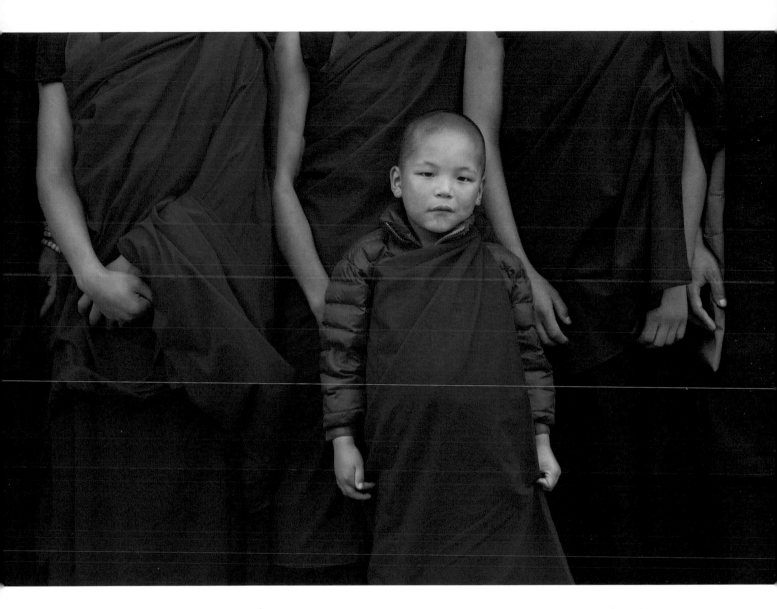

When our bus pulled up to one of the oldest Buddhist monasteries in Paro, Bhutan, there was a small group of young monks standing under some nearby trees talking with one another. As my students and I approached, we were quick to notice a very young monk, who we later found out was six years old. We asked if they would form a line, with the six-year-old in front, and this is one of the resulting images. Note the repetition of arms and bodies, and how this pattern plays a supporting role to the young monk, who breaks the pattern of the background. The entire scene is all but cloaked in shades of red, speaking perhaps to the passion and dedication of a lifestyle committed to the study of Buddhism.

Nikon D7200, Nikkor 18–300mm lens at 80mm, ƒ/10 for 1/200 sec., ISO 400

COLOR AND VISUAL WEIGHT

No one (as yet) seems to have determined why we perceive colors as having weight, from light to heavy, yet there seems to be universal agreement that we do. Since this is a book aimed at photographers and not scientists, I am going to avoid in-depth discussion of things like chroma, value, and hue—and which one, two, or three of these qualities is most responsible for our perception of visual weight—since it won't change the fact that it exists. There is also no universal agreement on the *purpose* of visual weight, but you can bet that I will speculate, briefly, about its main attributes.

Let's start by noting that there are, of course, other factors besides color that influence our perception of visual weight. Obviously, the *size* of a subject is one consideration. The larger a subject is and the more area it takes up in the overall composition, the more importance it will be assigned by the eye/brain. Another factor is perceived *volume* or *mass*. Side-lit subjects appear heavier because form is now revealed; and when we see a subject's form, we see it as something with mass. If you are heading out to shoot landscapes, it's important to know that low-angled sidelight renders form, volume, and mass to a landscape in addition to elevating a subject's texture. More often than not, the most memorable landscape compositions are shot in low-angled sidelight.

Studio portrait and still-life photographers also use sidelight for the same reason: to lend volume and fullness to a face or still life. You can see this effect for yourself by placing an orange near a window and shooting it both side-lit and front-lit, as I have done here.

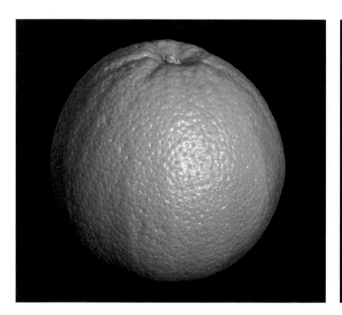

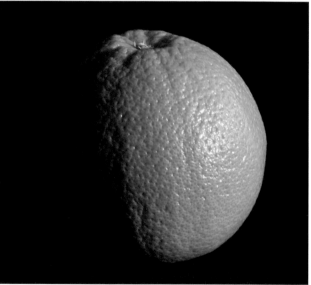

In this first example we see the shape of the orange, and yes it is round but not quite as full as in this second image of that same orange. The frontlight of the first image is more about *shape* and the sidelight of the second image is about both shape and form and of the two, the sidelit shape has the appearance of more visual weight; it feels heavier, yet it is that same orange in both images.

Both images: Nikon D810, Micro Nikkor 105mm lens, *f*/16 for 1/100 sec, 100 ISO

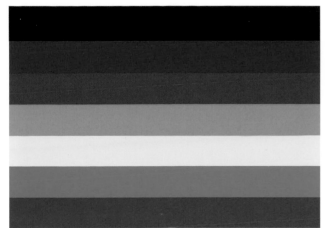 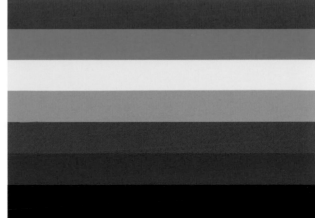

To help illustrate the idea of visual weight, I purposely grouped together a block of colors. In the first image, I placed black on top of the color block; in the second image, black is at the bottom. Most of the time, black and other dark colors and tones—such as deep red, burnt orange, and dark purple—work best near the bottom of

the frame. Our knowledge of gravity affects the perception that something is amiss in this first example. Because black is on top but feels heavier, the image feels top-heavy, as if it might fall over. In the second image, we feel safer because the composition has a strong foundation of heavy black to support the other colors.

Depth of field also influences a subject's visual weight. If your landscape is uniformly sharp, the image's overall visual weight is heavier than if only the immediate foreground were sharp. This is because the eye/brain assumes that whatever is in focus must be the most important. When you have a limited depth of field, such as one in-focus flower against an out-of-focus background, the flower will have much greater visual weight, even if the "mass" of out-of-focus background covers 99 percent of the composition. The brain *needs* to find something in focus, and even if that something is small, it will loom largest if it is the only thing in focus

Along with size, mass, and depth of field, color is a critical part of creating a subject's visual weight. Let's look at how. First, light colors are lighter, and dark colors are heavier. Generally speaking, compositions benefit when darker, heavier colors are at the bottom. Our understanding of gravity means that images feel top-heavy when darker colors are on top, as if the image will fall over.

Second, contrasts between light and dark colors have a great impact on visual weight. When a small

area of a darker color is surrounded by a large area of lighter color, the darker color screams for our attention, much like a ketchup stain on a white shirt. Although small in size, the ketchup looms large due to the shift in contrast between light and dark. The same is true of a small area of a lighter color surrounded by a larger area of darker color, like dandruff flakes on a black suit. In this case, the lighter-colored flakes grab our attention.

Given this, you can seek out compositions where lighter colors dominate yet the inclusion of a small darker-colored subject still attracts the spotlight. Placing a light-colored subject on a mostly darker background has the same effect. The most obvious of heavy colors, of course, is black. If you shoot a light-colored, lightweight subject against black, it's entirely possible that the lighter tone will appear protected by the arms of the black. Or it's just as possible that you'll feel the lighter-toned object is about to be swallowed by the heavier black.

In the example above, you might not notice the lone pink poppy smack dab in the middle of this very active composition. The image's overall sharpness favors the many flowers evenly; everything is of equal visual weight.

When I switch to a longer telephoto length, move in closer, and choose a large lens opening for a shallow depth of field, however, I am able to place all of the visual weight on that one pink poppy (see right). The eye and brain assume that whatever is in focus *must* be the subject, so it is now very clear that the pink poppy is the most important flower.

If you are looking for a great exercise on seeing color and understanding visual weight, head out the door and use lens choice and aperture to isolate single-colored subjects from their otherwise busy surroundings.

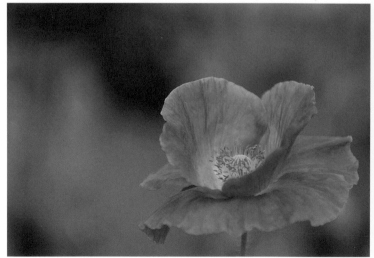

Above: Nikon D300S, Nikkor 70–300mm lens at 300mm, f/6.3 for 1/640 sec., ISO 320; right: Nikon D300S, Nikkor 24–85mm lens at 85mm, f/16 for 1/100 sec., ISO 320

Try as I might to photograph this elderly man and his cotton candy on a street in Guanajuato, Mexico, he continued to turn the pole, blocking his face with the cotton candy. After a minute or so of this cat-and-mouse exchange, I realized that not seeing his face was actually funny. It's one of those compositional mergers that seems to work. More than anything else, this is a composition about color. The visual weight of the light blue and light pink are experienced as fragile, airy, fluffy. They are playful and childlike, which works with the composition.

Nikon D810, Nikkor 24–120mm lens at 120mm, *f*/6.3 for 1/400 sec., ISO 100

Take a look at these two very different "landscapes": one a field of red tulips against a blue sky and white clouds, the other an abstract subject that mirrors the tulip scene in color and composition. For the purposes of explanation, turn this book upside down and look at the abstract landscape. When the red is at the top, the composition feels unbalanced, unstable. More often than not, darker colors like red are better composed near the bottom of the frame.

Above: Nikon D810, Nikkor 24–120mm lens at 120mm, *f*/22 for 1/60 sec., ISO 200; right: Nikon D810, Micro Nikkor 105mm lens, *f*/18 for 1/320 sec., ISO 400

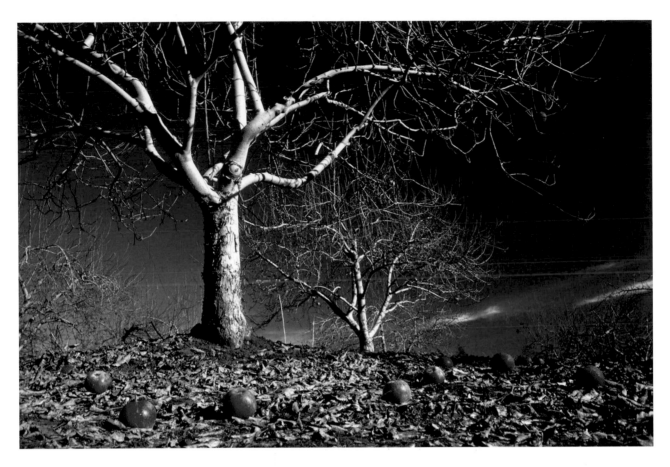

Red is a much heavier color than blue, in terms of visual weight. In the photo you see here, the apples had indeed fallen to the ground on their own, but they had not fallen exactly where I wished they had. Because red is heavier, I wanted the apples at the bottom of the frame—not only because that is where gravity suggests they should fall but to contrast against the much lighter-weight blue sky. So, in the name of artistic license, I rearranged the apples into the more compelling composition you see here. To drive my point home, look at the second image, which has no apples. (I removed them using the Content Aware tool in Photoshop.) This composition screams, begs, for something in that foreground; anything but dead brown leaves!

I have met some photographers who struggle with the idea of "messing" with nature. I've said it before and I'll say it again: great chefs can't prepare great meals without cutting, squashing, mixing, steaming, peeling, cutting, simmering, boiling, stirring, and blending the food, and then arranging it on a plate in a compelling fashion. So, if you want to create truly compelling images, start "cooking"!

Nikon FM, Nikkor 20mm lens with polarizing filter, *f*/22 for 1/30 sec., ISO 100

MAKING COLORS POP: ADVANCING AND RECEDING COLORS

Years ago, Kodak was fond of telling photographers to "put a little bit of red in your compositions and the world will notice." This is because red is the most *advancing* color. It immediately comes forward to grab the viewer's attention, no matter where it is in the composition. In fact, all warm colors—not only red, but also orange and yellow—*advance*. Cooler colors, such as blue and green, *recede*, falling into the background. By combining advancing and receding colors, you can make your subject pop and add depth to your image.

If your composition calls for a limited depth of field (such as a portrait), it's far more exciting to compose an in-focus foreground of a warm, advancing color against a background of its complementary, cooler counterpart: red against green, orange against blue, yellow against violet (or purple). And because the warmer color is *advancing* and the cooler background color is *receding*, the overall composition will have even greater depth.

Outside of Austin, Texas, my students and I came upon a windswept oak tree surrounded by Texas blue bonnets and a lone sunflower. Reaching for the wide angle I was quick to create an up close and personal composition of the foreground flowers, and with my focus manually pre-set to the one meter mark, and with the aperture set to *f*/22, I was assured of recording exacting sharpness from the immediate foreground to the distant blue sky. Note how the much more advancing yellow, in contrast to the receding blue bonnets, helps to emphasize both depth and perspective.

Nikon D810, Nikkor 18–35mm lens at 18mm, *f*/22 for 1/60 sec., ISO 100

When I stumbled upon this scene in the Jardin des Tuileries
in Paris, I was quick to compose and shoot, since it was
anyone's guess when this man might awaken and move on.
Even though he is a small figure in the frame, the eye/brain
assumes he is the main subject, thanks to his red shirt,
which advances toward you, and the complementary and
receding colors surrounding him. The receding colors cre-
ate an added feeling of depth in the overall composition.

Nikon D800E, Nikkor 24–120mm lens, ƒ/11 for 1/80 sec.,
ISO 400

USING COLOR AS A SEAMLESS BACKGROUND

Most of us are familiar with the use of out-of-focus, seamless backgrounds by studio photographers, especially those who shoot portraits. Often, these backgrounds are a single color, such as white, black, or gray. In other cases, the backgrounds are a muslin material, adding texture to the background. The sole purpose of these backgrounds is to create a cleaner overall composition, giving the viewer no choice but to look at the man, woman, or child.

Unlike the often limited and single-colored backgrounds found in portrait studios, however, there is a truly unlimited supply of seamless backgrounds to be found outside of the studio, in all manner of tones, textures, and colors. And the best part is, they are free. Once you begin to realize this, you can expand your vision in an unlimited number of ways.

As you look at the following examples, note how I use out-of-focus color backgrounds to not only create cleaner compositions but to add impact, thanks to the contrast between the color of the background and that of the main subject.

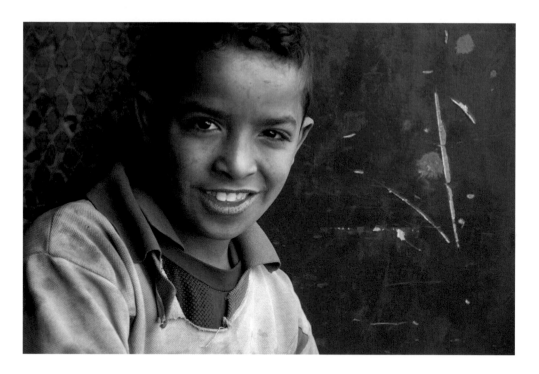

I met this Egyptian boy in Cairo several years ago. He was hard at work making ornamental fencing. I asked his father if he would mind if I posed his son against a nearby background, and he said sure. It was over within thirty seconds, and I moved on to other subjects in the neighborhood. It wasn't until several days later, after returning to Dubai, that I sat down to edit these photographs and was absolutely awestruck by how the color and design of the boy's shirt almost exactly mimics the background. I had never met the child before, nor been to this location, yet together he and I created a very serendipitous moment. Note my deliberate choice to compose a larger part of the frame with red, thus casting the color blue into a smaller, supporting role. The contrast of the advancing red against the receding blue intensifies the sense of depth and distance.

Nikon D800E, Nikkor 24–120mm lens at 75mm, *f*/11 for 1/200 sec., ISO 200

Richard lives in Key West, Florida, near the port where many of the cruise ships dock. More than twenty years ago, while in his forties (and feeling "more youthful at that time," he says), Richard left Los Angeles on foot and walked all the way to Key West. Since then, he has found no reason to be anywhere else. I have returned to Key West on several occasions, and each time I make it a point to visit Richard, who continues to be happy and at peace in his humble surroundings.

It was during my first encounter with Richard that I asked if I could take his portrait. He was more than happy to oblige. After looking around a bit, I discovered a small, somewhat distressed, bright orange piece of plywood that would not only create some welcome color contrast but also render a clean, non-distracting background.

Nikon D800E, Nikkor 24–120mm lens at 120mm, f/6.3 for 1/320 sec., ISO 200

I met this young man at the fish market in Deira, Dubai, and was immediately struck by the color and intensity of his eyes. Fortunately, he was near a vendor who was selling, among other things, burgundy-colored sacks of onions. I wondered if I could find a point of view that would allow me to incorporate the burgundy sacks into the background and—with the aid of my telephoto lens, a narrow angle of view, and a relatively large aperture—turn them into an out-of-focus burgundy tone that would contrast with the green in the man's headscarf and eyes. Once I determined it was possible, I simply asked this young man to walk over to the spot where I needed him to stand.

Left: Nikon D800E, Nikkor 70–300mm lens at 70mm, f/5.6 for 1/400 sec., ISO 200; below: Nikon D800E, Nikkor 70–300mm lens at 300mm, f/5.6 for 1/400 sec., ISO 200

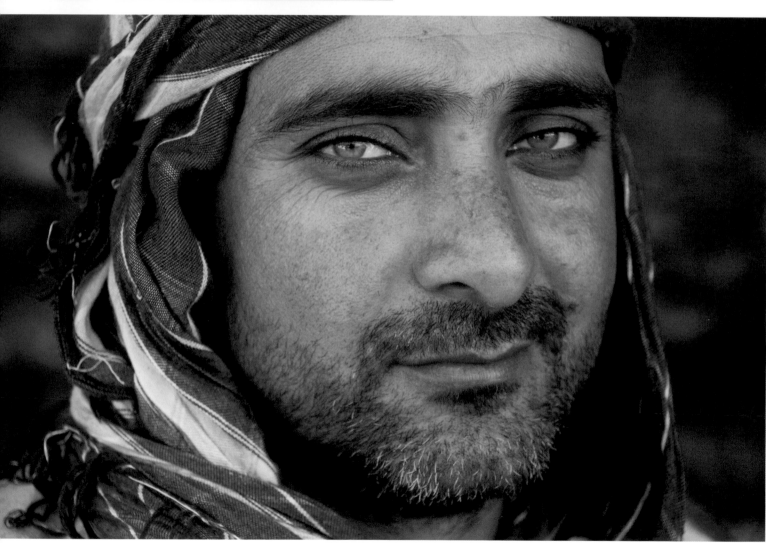

One morning, on the streets of Muscat, Oman, this woman asked me to take her photo. I was quite surprised, since I am always the one approaching potential subjects. She was quick to explain her frustration with getting a good "selfie," and hoped I could come up with something better.

I suggested we walk up the street where I could see a deep blue wall. She was wearing a yellow blouse and a scarf with bits of red, and the blue background would offer a welcome contrast. As luck would have it, a subtle gust of wind came up and, thanks to my shutter speed of a 1/30 sec., I recorded some subtle blurring in her scarf. Not only does the blue contrast with the red and yellow, but because blue is a recessive color and yellow and red are advancing colors, the contrast creates the impression of depth and distance.

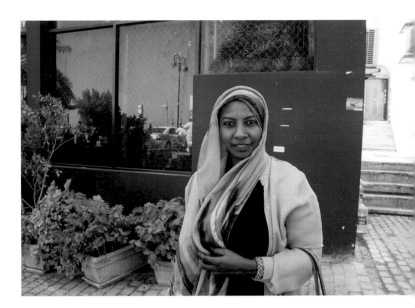

Both images: Nikon D800E, Nikkor 24–120mm lens, ƒ/5.6 for 1/640 sec., ISO 200

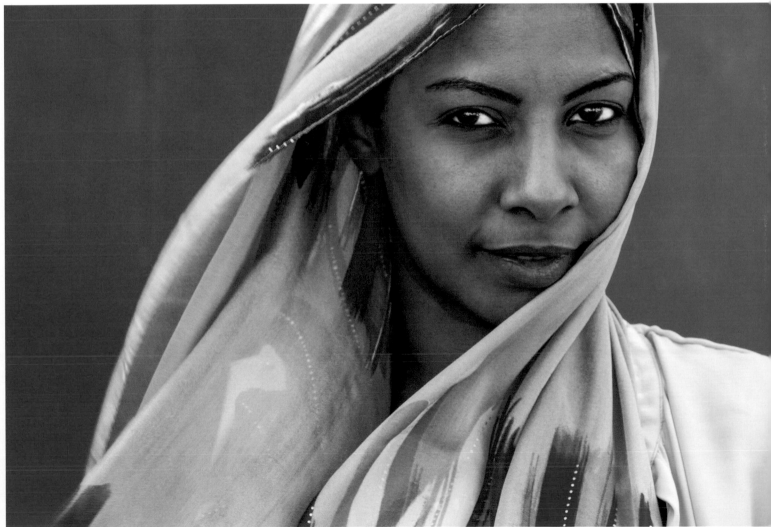

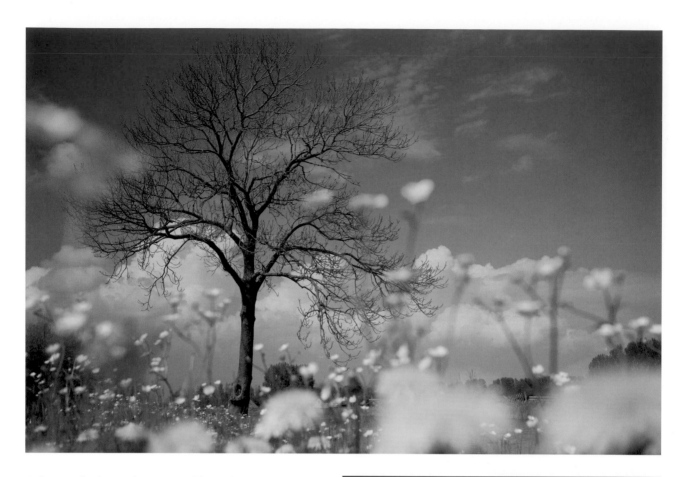

Color can also be used as an out-of-focus foreground, to frame a focused subject in the background. Many people driving down this small country road in West Friesland, Holland, would no doubt notice the blooming buttercups on the side of the road. They might find a place to pull over and create a composition where the flowers, dike, and distant house are all in focus: a "simple" landscape. But I suggest instead looking at these flowers as potential out-of-focus splashes from a small paintbrush, thrown onto a canvas. The yellow dabs of out-of-focus color serve to frame the large tree, blue sky, and white puffy clouds in the background.

Normally, out-of-focus backgrounds and foregrounds call upon the telephoto lens, but in this case, a 50mm focal length offered the best overall angle of view. And to make certain these yellow "paint dabs" were out of focus, I shot at a large f/5.6 lens opening.

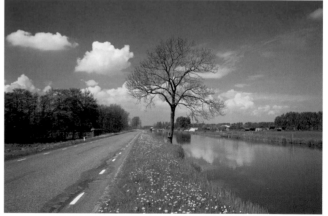

Above: Nikon D800E, Nikkor 24–85mm lens at 50mm, f/5.6 for 1/640 sec., ISO 100; right: Nikon D800E, Nikkor 24–85mm lens at 50mm, f/16 for 1/80 sec., ISO 100

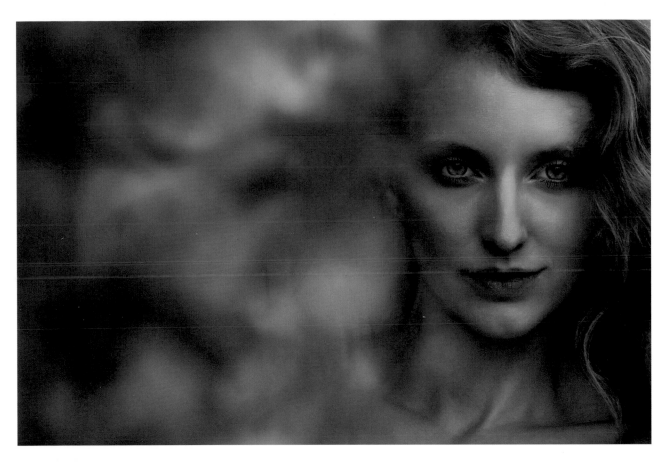

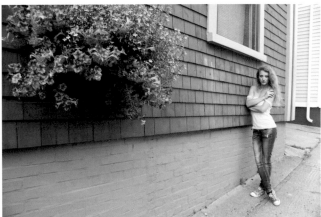

How many times have you walked past a flowering window box or a basket of overhanging flowers, never giving a thought to their potential use as out-of-focus color? When my students and I came upon this large window box of colorful flowers during a workshop in Lunenburg, Nova Scotia, the students were quick to take out their macro lenses and start shooting close-ups of flowers. I suggested we combine a telephoto lens with a large lens opening to use the flowers as an out-of-focus foreground, and the students jumped in with enthusiasm, photographing their fellow-student-now-model Maja. With my Nikon D7200 camera and Nikkor 18–300mm lens, I zoomed out to the 200mm range and filled up the left two-thirds of the frame with out-of-focus flower tones, framing the distant Maja as she leaned against the side of the building.

When using out-of-focus colors in the foreground this way, be careful not to place tones of color in areas that will overlap awkwardly onto the focused subject, such as on the eyes, thus causing a distraction for the viewer.

Nikon D7200, Nikkor 18–300mm lens at 200mm, ƒ/5.6 for 1/320 sec., ISO 200

USING MOTION: THE "BRUSHSTROKES" OF COLOR

In the days of film, we often referred to film as "the photographer's canvas." Today, of course, we call that canvas the digital sensor. Within your arsenal of creative approaches to image-making, do you overlook the many opportunities to create a multitude of often unexpected "brushstrokes" on that canvas? Here are a few techniques for using color to add texture to your images.

As a good starting point, try "painting with motion" by blurring a moving subject as a brushstroke of color against a sharp background (and foreground). To do this, mount your camera and lens on a tripod to keep it still as the subject moves across your frame. You want to aim for shutter speeds of 1/15 or 1/8 sec., so use the lowest ISO (such as 50 or 100) and smallest aperture possible,

$f/16$ or $f/22$ when necessary to get there. If necessary, add a 3- or 4-stop neutral-density filter. Because the only movement will come from the subject, it will record as the sole blur in an otherwise sharp composition.

A second technique is to freeze a moving subject sharp against a background and foreground of blurred brushstrokes. This is called *panning*, and it relies on the photographer using a shutter speed of 1/20 sec., 1/25 sec., or 1/30 sec. while, more often than not, handholding the camera. In addition to the correct shutter speed, compositions of this type rely on the photographer's ability to steadily track the subject as it moves, all the while keeping the subject in the same spot in the frame.

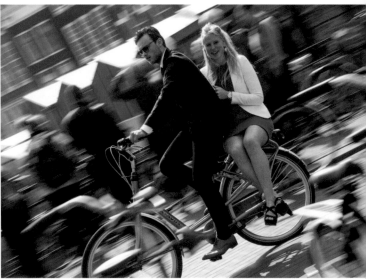

In the first image, a red car passes through a color block of green, gray, white, yellow, and blue. Because the only movement was the car, it is the sole blur in an otherwise sharp composition. In the second photograph, a young bicycle-riding couple is sharp against a background and foreground of brushstrokes, an effect created by panning. Either of these two effects will produce a sense of motion.

Left: Nikon D810, Nikkor 24–120mm lens, $f/22$ for 1/60 sec., ISO 100; above: Nikon D810, Nikkor 24–120mm lens, $f/22$ for 1/20 sec., ISO 100

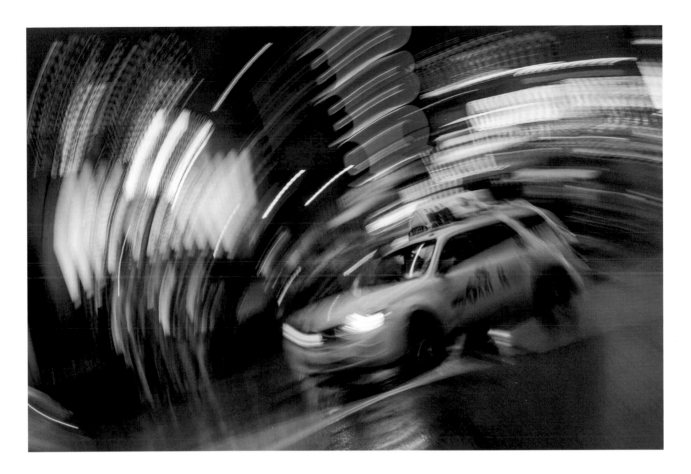

Spin zooming is a third technique. It requires slightly slower shutter speeds, such as 1/8 or 1/4 sec., and a "street zoom" lens (such as a 24–120mm, 24–70mm, or 18–105mm zoom). You just frame up the subject at the wide-angle end of your lens, and, while following the moving subject, hold the zoom ring of the lens and move the camera in a clockwise (if shooting with Canon) or counterclockwise (if shooting with Nikon) direction.

As a general rule, always use the lowest ISO possible when creating brushstroke effects. The lowest ISOs—when combined with the smallest f-stops—will force the slowest shutter speeds, and slow shutter speeds are what this is all about. You may also need to add a polarizing filter or a 3- or 4-stop neutral-density (ND) filter. Just like sunglasses, the polarizing and ND filters dramatically reduce the brightness of the light, forcing you to use slower shutter speeds.

If all one did on any given morning was stand across the street near McDonald's in New York City's Times Square or on 42nd Street between Seventh and Eighth Avenues, with the sole intention of creating motion-filled images of yellow taxis, you would be hard-pressed to walk away with zero results. Both of these locations are perfect for trying your hand at panning and spin zooming. Here, I spin zoomed this photo of a yellow taxi during a rainfall, the streets reflecting color from nearby neon lights.

Nikon D800E, Nikkor 24–85mm lens, f/11 for 1/4 sec., ISO 400

For several months, there was an amazing and very telling mural on display at the corner of Bowery and Houston in New York City. This mural depicted an angry lime-green Incredible Hulk portrayed as a baby and surrounded by parodies of current American advertisements. With my camera securely mounted on a tripod, I was able to capture the yellow brushstroke of a passing taxi. But how do I explain the pair of legs seen through the taxi's window? The legs are, of course, attached to a pedestrian, but the rest of the pedestrian was "painted over" by the brushstroke of the yellow cab.

Nikon D800E, Nikkor 24–120mm lens at 120mm, *f*/22 for 1/25 sec., ISO 50

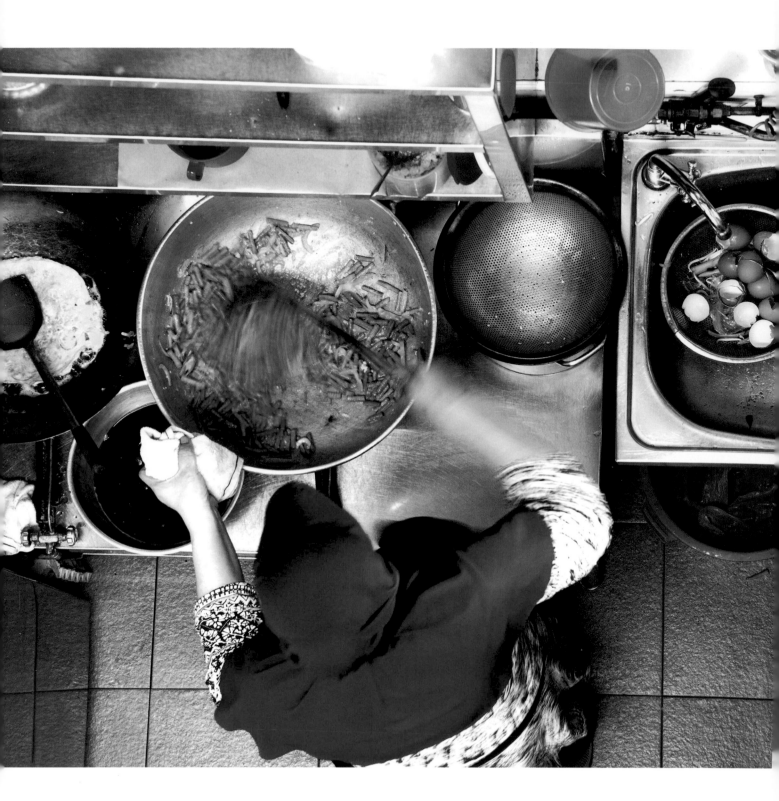

One of the easiest ways to capture brushstrokes of color is to simply look up through a stand of trees and spin on your feet, all the while looking up and shooting at a slow shutter speed. —SUSANA

Nikon D810, Nikkor 24–85mm lens, *f*/22 for 1/8 sec. with 3-stop ND filter, ISO 100

LEFT: This woman is busily preparing food in the kitchen. Standing in an open stairway overhead, I was able to press the camera against the short wall that was part of the stairway and, shooting straight down with my exposure at *f*/16 for 1/8 sec., record anything that wasn't moving in exact sharpness, while getting brushstrokes from anything that was moving—in this case, the woman's arm and the vegetables she is stirring. —SUSANA

Nikon D7200, Nikkor 24–85mm lens, *f*/16 for 1/8 sec., ISO 100

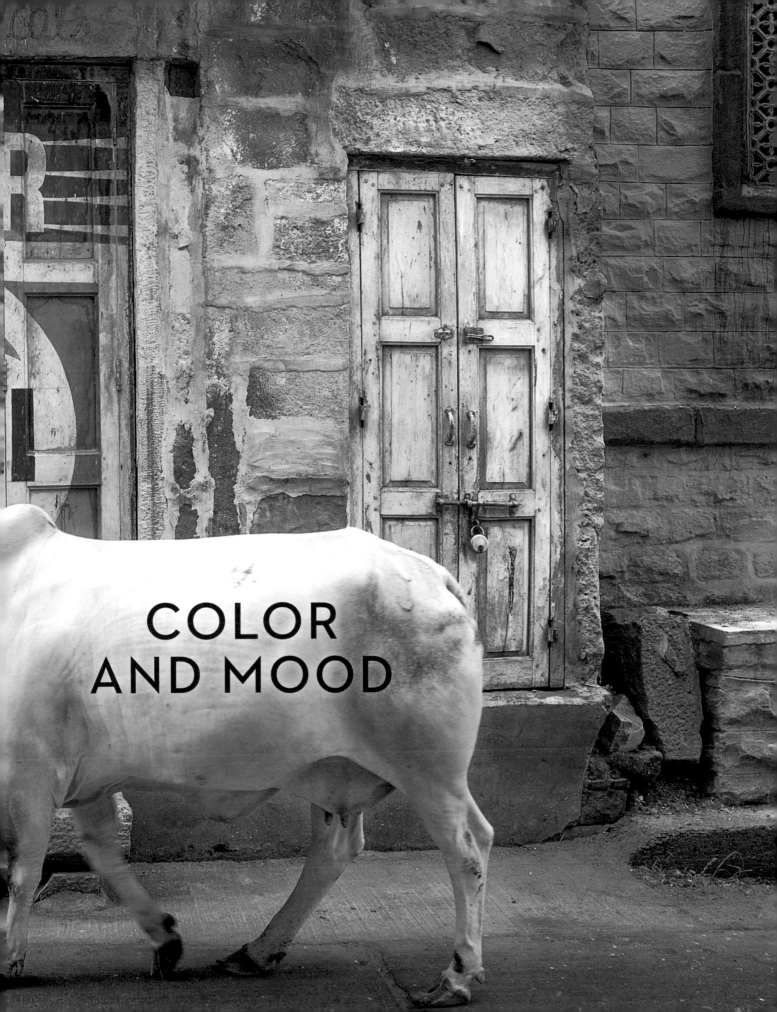

COLOR
AND MOOD

THE PSYCHOLOGY OF COLOR

Do you recall the first time that a color in a given photograph had a memorable impact on you? Did you or someone else take that particular photograph? Do you remember what color it was?

Most of us have at least one, if not several, favorite colors. And no wonder—colors impact our mood, our frame of mind. The color choices in your compositions are your choices, even when you insist that the person you photographed was a stranger and you had no say in the matter. But you *did* have a say, indicated by your willingness to invest the time to create that image. Consciously or subconsciously, we all constantly make quick decisions about what we choose to photograph, many of which are made in large measure because of the subject's color.

Look carefully at these two photographs. What is the difference? If you said the background, you'd be correct. Now that you see that difference, which do you find more appealing? Most people choose the image with the green background. The orange butterfly and purple flowers set against the green make a wonderfully soothing composition.

In the other image, the orange background competes with the tones of the butterfly and is disruptive to the regal purple flowers. Orange is an excitable, energetic color, while purple is wiser, more elegant. In effect, the orange background is "noisier" and more disruptive than the flowers.

Both images: Nikon D810, Nikkor 200–500mm lens with 36mm extension tube, *f*/7.1 for 1/800 sec., ISO 200

RED

Throughout history, no color has played a more important role than red. The color red symbolizes leadership, decisiveness, determination, and a very tight and focused vision. Red is the color of passion and love, celebrated every February 14 the world over. Red is also the color of anger, blood, danger, and war. In Chinese culture, red is a safe color of good luck, considered by many to keep the demons away. Some people report getting an appetite when they see red, which is why it is used in the logos of many fast-food chains.

Red is a bright color on the visible spectrum, the second most advancing of all colors (after yellow). Red is also a dominant color. Line up six men wearing black suits, white shirts, and a different colored tie, and your eyes will land on the man with the red tie first. Given that red is such an attention-seeking color, think carefully about where you place it in your composition, as it will immediately draw your viewer's eye.

Researchers at the University of Arizona have found a gene for seeing the color red and it sits on the X chromosome. Since women have two X chromosomes and men only one, women see red at twice the "volume" as men and are also attuned to its many variations, from crimson to burgundy, whereas men, for the most part, only see red. If you are filling your frame with crimson red, underexpose by –1; if it's red midtones, set your exposure to –2/3.

The color complement to red is green.

Upon entering this hotel room in a remote small town in New Mexico, I was immediately taken back in time at least forty years. I could easily imagine an attractive blond heroine being found unconscious just on the other side of this couch, with a tipped-over bottle of alcohol and an empty bottle of pills on the floor. It was true after all: her lover was married with two young children and had no intention of ever leaving his wife! And it's all here—all of this passion, this intense love—all in red. —SUSANA

Canon EOS 1D Mark II, Canon 28–70mm lens at 40mm, f/4.0 for 1/50 sec., ISO 400

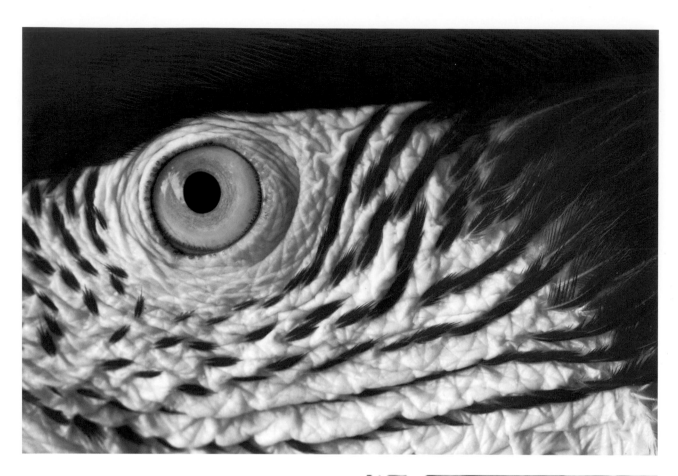

Every time I visit Singapore, I make it a point to visit the butterfly and insect gardens on Sentosa Island. On this particular day, I had the opportunity to photograph one of two macaw parrots now living at the park. I wanted to record an extreme close-up of the parrot's eye—but without being bitten by its very large and very sharp beak. When trying to get extreme close-ups of live and unpredictable subjects, one solution is to combine your telephoto zoom lens with an extension tube or two, which turns your zoom into a very close-focusing macro lens. You're then able to record an extreme close-up magnification, but from a distance of three or four inches—much safer than the half inch necessary with a 50 or 60mm macro lens. (Yes, I am aware that one can purchase macro lenses in the 150mm, 180mm, and 200mm ranges, but given the fifteen-hundred-dollar price tag, this is a much cheaper alternative.) The good news is that the parrot didn't manage to make a single scratch on my lens, though he definitely left his mark on the lens barrel.

Nikon D7200, Nikkor 18–300mm lens with 36mm extension tube, ƒ/16 for 1/160 sec., ISO 400

Recently, I was reminded once again why I usually set my alarm to wake me at or near sunrise. It was a Sunday morning, and by 6 a.m. I was en route to Times Square with my students as part of a New York City workshop. I felt confident that Times Square would be relatively empty at this hour, left to only my students and perhaps a handful of other people. Much to our delight, this set of red stairs was getting an early-morning cleaning by a young man in similarly colored clothes, with a nearby yellow neon billboard for *The Lion King* reflected in the water.

Nikon D810, Nikkor 24–120mm lens at 120mm, *f*/22 for 1/125 sec., ISO 800

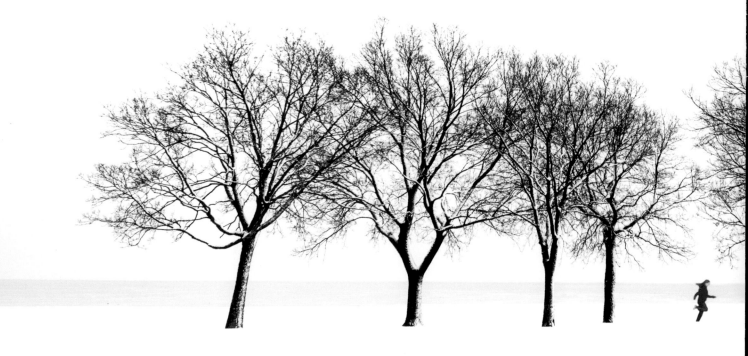

In downtown Singapore, near the Funan Center, there is a covered overhead walkway with a highly reflective surface that I would never have noticed had not some crackling thunder caused me to look up. Within several minutes, an afternoon downpour found me safe and dry under this covered walkway, merrily shooting away. Of the many compositions I shot over the next forty-five minutes, this is one of my favorites. If you aren't quite sure what is going on in the image, turn the book upside-down and it might make more sense. Notice the other photographer in the lower right-hand corner? A funny thing happens when you look up with your camera: others start looking up, too. In this case, I counted seven other photographers shooting these colorful reflections and it's easy to understand why! —SUSANA

Nikon D810, Nikkor 24–120mm lens at 78mm, *f*/7.1 for 1/160 sec., ISO 2000

LEFT: Perhaps the greatest demonstration of the power of red can be seen in this photograph, a predominantly white, almost monochromatic composition taken on Chicago's Lake Michigan shoreline in subzero temperatures. Try as you might to ignore it, that small dab of red changes the entire image. Red's aggressive nature means that you cannot ignore its presence. It is the noise heard in an otherwise quiet room when a large glass vase falls from a high shelf, smashing onto the tile floor.

Note that if you venture out into extremely cold weather, the good news is that your camera and lenses will not suffer damage. Your primary concern should be the camera's battery, which can drain quickly in severe cold. It's best to take several fully charged batteries, keeping them tucked securely inside your warm winter coat.

Nikon D800E, Nikkor 24–85mm lens, *f*/11 for 1/320 sec., ISO 200

Every time I go to the fish market in the Deira neighborhood of Old Dubai, I see the green and blue wheelbarrows used by workers to deliver fish to the cars of waiting patrons. Needless to say, when I saw this red wheelbarrow—the first red one I had ever seen there—I stopped the young man pushing it and politely (though, I must be honest, also forcefully) asked if I could borrow it for five minutes. He was initially reluctant, so I offered to buy him a brand-new wheelbarrow (which cost twelve dollars) and he quickly took my offer. I now had all the time I needed to shoot numerous compositions of a basket of fish against this remarkably textured wheelbarrow with its contrasting colors of red and green.

Note that when shooting a subject in open shade under a blue sky, as I was here, I normally recommend changing your white balance to Shade, to reduce the bluish cast. In this instance, however, I didn't want to reduce the bluish cast on the fish, because I wanted it to serve as a color complement to the surrounding red and green. As a result, I left my white balance on the Direct Sunlight WB setting (called Sunny on Canon cameras).

Nikon D800, Nikkor 24–120mm lens, f/11 for 1/100 sec., ISO 400

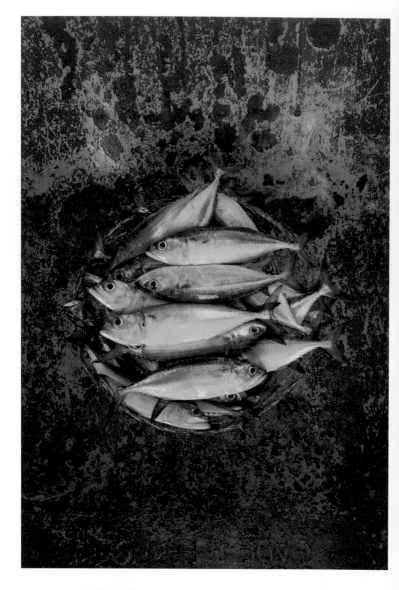

The streets of St. Louis were wet and quiet on this early Sunday morning, so the sight of this pretty young woman with bright red hair was a welcome sight. How to take advantage of this opportunity? Keep it simple. Find a clean background and move in close to fill the frame. In this case, that clean background turned out to be the blue inside lining of her jacket, which, after asking her to remove it, was held behind her by one of my students. The contrast between the always advancing, vibrant red and the shy, receding blue—combined with soft light from the overcast day—made for a simple yet vibrant portrait.

Nikon D810, Nikkor 70–300mm lens at 300mm, *f*/6.3 for 1/320 sec., ISO 200

ORANGE

I remember arriving in Paris on the same day the global authority on color, the Pantone Institute, announced that Tangerine Tango (orange) would be its color for the year 2012. Soon, fashion designers—some famous, some not-so-famous—were completely focused on making orange clothing and accessories. Why did this receive such enthusiasm? Orange is a divisive color, perhaps the most divisive. You either love it or you hate it. Seldom is there room for a middle ground with orange.

Orange is a warm color, often associated with health and vitality. In Japanese and Chinese cultures, orange symbolizes happiness and love. Orange is flamboyant, loud, even cocky, yet unlike red, orange is often not taken seriously. It's considered too playful, too immature, to be able to lead.

Until the sixteenth century, orange was referred to by the old English word *geoluhread*, meaning "yellow-red" ("geolu" is "yellow" and "read" is "red"). The word "orange" comes from the Spanish word *naranja*, which itself comes from the Sanskrit word for "orange tree": *nāraṅga*. Interestingly, the word "orange" does not have a single English word that rhymes with it.

In many ways, orange can be seen as a diluted red. It is still an advancing color; its use in orange construction and roadwork cones speaks to its ability to garner our attention. Just like deep crimson red, dark oranges (such as burnt sienna) should be shot at −1 exposure to avoid overexposure.

The color complement to orange is blue.

Silver Falls State Park in Oregon continues to see larger and larger crowds every October. And no wonder: at almost every turn, and throughout its eighteen miles of hiking trails and eleven waterfalls, yellow, red, and orange colors abound. This composition of the South Falls certainly has no shortage of color as the final remnants of summer green give way to yellow, red, and of course geoluhread, too! Note that I used a polarizing filter to eliminate gray glare from the overcast sky, which is normally seen on wet leaves when it rains.

Nikon D810, Nikkor 24–120mm lens at 50mm with a polarizing filter, ƒ/22 for 1/4 sec., ISO 100

Orange, the color of fire! What better way to say hello to orange than with a single match and a macro lens? With my camera and Micro-Nikkor 105mm lens mounted on a tripod, I stuck a match into a small mound of putty. At a time like this, a ring flash really comes in handy. With the ring flash mounted on the front of my macro lens and set to TTL mode, I merely had to set an exposure for the flame of the match. After lighting a sample match in my darkened room, I set my aperture to f/22 for deep depth of field and adjusted the shutter speed for the bright flame until 1/60 sec. indicated a correct exposure. (Keep in mind that this was the exposure for the flame, not for the wood of the match itself.) I was now ready to take the shot. I turned on the ring flash and, just before pressing the shutter release, lit the match. As you see here, I recorded not only the flame but also the color of the non-burnt portion of the match.

Nikon D3X, Micro-Nikkor 105mm lens with three Kenko extension tubes, f/22 for 1/60 sec., ISO 200, tripod, Sigma ring flash

Most sunrises are *not* vivid orange like sunsets. Do you know why? The air in the evening has more dust particles, pollutants, and such from all of the activity of the day. Overnight, much of that activity comes to a halt and the dust settles, so by sunrise the early-morning light is not piercing through nearly as much atmospheric haze and you are more likely to get a simple orange than the complex orange-reds of sunset.

For this image, taken on a warm evening in Muscat, Oman, my primary concern was to freeze the splashing water. Freezing the motion of water requires a shutter speed of at least 1/500 sec., if not 1/1000 sec., so I set my shutter speed to 1/1000 sec. and, with the camera in manual metering mode, adjusted my aperture until *f*/16 indicated a correct exposure. I then asked a student to start kicking up some water. This is one of the nineteen images I shot as the sun set.

Nikon D800E, Nikkor 24–120mm lens at 35mm with magenta filter, *f*/16 for 1/1000 sec., ISO 640

The next time it rains, consider hanging out around bus stops. Rain-soaked bus windows offer welcome texture and, when combined with the often-preoccupied passengers inside, make for fascinating exposures. If you use high ISOs in the 1000–1600 range, you should be able to use fast enough shutter speeds to handhold your camera while still using apertures of *f*/11 to *f*/13 for extra depth of field. In this image, the overall orange tone conveys the cozy warmth inside the dry bus.

Nikon D800E, Nikkor 24–120mm lens, *f*/11 for 1/100 sec., ISO 1600

It is easy to imagine this airplane is taking off toward some exotic vacation destination, thanks to the warm orange resonating around the deep yellow sun. Almost all of our preconceived notions about orange are rooted in feelings of warmth, both in our primitive relationship to fire and the warmth of the summer sun. Not surprisingly, most of us respond warmly to the many sunset photographs posted on Facebook and Instagram.

Want a tip for taking more creative photos? Simply spend more time out and about with your camera gear— at least once a week. To get this image, it's true that I went to the airport with the hope of shooting airplanes against a sunset sky. I had no control over the runways, the weather, or the planes and their directions, but I was *there*—and being there was key!

Nikon D800E, Nikkor 800mm lens with a TC1.4 teleconverter (in effect making the lens a 1200mm), *f*/16 for 1/250 sec., ISO 200, tripod

This scene on the steps of what locals call "Monkey Temple" in Jaipur, India, is by no means the norm. It is what this mother (who stands outside the frame) has chosen to do with her baby to earn income from tourists passing by with their cameras. The mother was quick to point out that the cobra was not venomous and that she was at all times handling the reptile. After being assured that the baby (and I) were safe, I settled in and started photographing the baby and snake, just as the mother had hoped. Notice how the color orange, both in the background and in the baby's cap, lends an overall feeling of warmth and heightens the contrast between the sweet face of the baby and what the reptile represents. The bit of orange on the snake's skin is actually a reflection of the nearby mother's clothing. —SUSANA

Nikon D7100, Nikkor 24–85mm lens at 85mm, ƒ/5.6 for 1/250 sec., ISO 400

Anyone for dirty orange? Derivatives of the color orange, in particular the darker shades such as burnt sienna, Persian orange, and burnt umber, are often referred to as "earth tones," but I like to call them "dirty orange." And dirty orange is exactly what I thought of when photographing this emu at the Singapore Zoo several years ago.

When photographing a subject against a background of almost identical tones, as here, a limited depth of field is key to helping your subject stand out. Without fail, the first things the eye/brain looks for when scanning an image are focus and sharpness, even before color. By using a large lens opening, I was able to keep the emu sharp, thus placing all of the focused visual weight on him and separating him from the out-of-focus background. —SUSANA

Nikon D7100, Nikkor 18–300mm lens at 270mm, ƒ/6.3 for 1/250 sec., ISO 800

Lying on my back while handholding my camera and lens, I was intent on recording a "starburst" on this California poppy against the strong backlight of the midday sun. To record a starburst when shooting backlit scenes with a wide-angle lens or, as in this case, a full-frame fish-eye lens, you must set a small aperture of f/16 or f/22.

For a backlit scene like this, first set your exposure manually with the sun hidden behind the flower. With my aperture set to f/22, I hid the sun behind the flower and adjusted the shutter speed until 1/250 sec. indicated a correct exposure. I then shifted my point of view slightly to allow a small piece of the sun's light to peer out from the edge of the flower and fired the shutter. If you are using a wide-angle, rather than a fish-eye, lens remove any UV or skylight filters as this may cause unwelcome lens flare. And always make sure your lens is clean, as a dirty lens can also cause lens flare.

Nikon D810, Nikkor 15mm full-frame fish-eye lens, f/22 for 1/250 sec., ISO 200

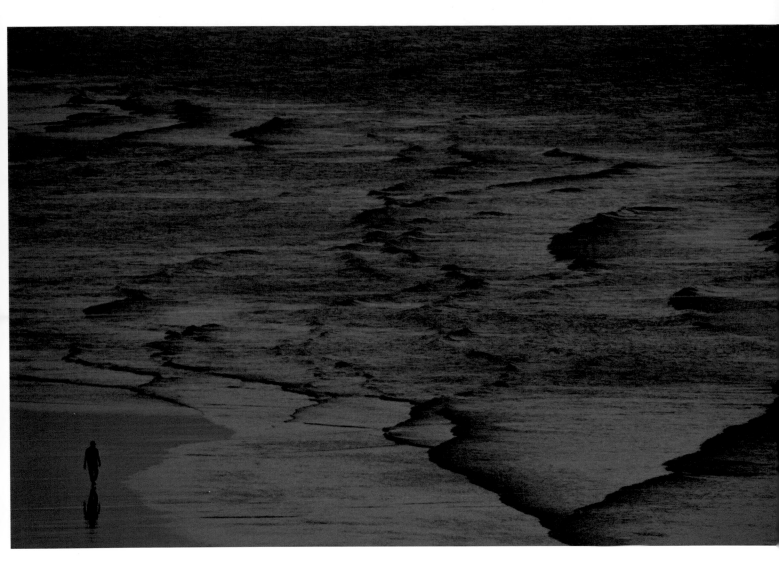

One warm February day, I sat on the deck of the Crowne Plaza Hotel in Muscat, Oman, chatting with one of my students as we watched the sun sink toward the horizon. From this viewpoint, there wasn't much to shoot, other than a lone palm tree with the sun setting behind it, something I can easily shoot in Florida or Hawaii. However, ten minutes after the sun set, the sky began to turn a vibrant orange-magenta-blue color, and I spotted a lone individual walking along the distant shoreline. I leapt up, grabbed my Nikon

D7200 and Nikkor 18–300mm lens, and went farther out onto the balcony to get a clean shot of incoming waves and the contrasting shape of the person—all bathed in the warm power of the color orange.

Nikon D7200, Nikkor 18–300mm lens at 300mm (with an effective focal length of 450mm), *f*/16 for 1/200 sec., ISO 400

YELLOW

Yellow is cheerful, vibrant, and, boy, is it bright. Yellow is the most visible color in the spectrum, and surprise, surprise, it is the first wavelength of light seen by all of us. In fact, yellow is roughly two and one half times brighter than red. However, yellow is not nearly as dense as red, and as a result, we experience red to be just a wee bit closer to us than yellow. If you are filling your frame with bright yellows, set your exposure to +1.

In China, yellow is considered by many to be the most beautiful and prestigious color. The Chinese feel that yellow sits at the center of yin and yang, and thus yellow is also seen as being neutral. Yellow brings balance to life. And while Western cultures associate yellow with cowardice, Asian cultures see it as heroic.

When the human body is yellow, it is a far cry from being energized or heroic. A yellow body is jaundiced, yellow teeth indicate either poor hygiene or the teeth of a smoker, and the "'yellow jack" is the term given the yellow flag that hangs outside an area that is under quarantine; and, of course, yellow fever took many lives in the 1800s.

Yellow signifies courage in Japan, sadness in Greece, jealousy in France, and food (corn) for the Aztecs. Yellow is also used to indicate caution and warnings. Einstein believed that yellow stimulated mental processes, activated the memory, and encouraged communication.

The complementary color of yellow is violet (or purple).

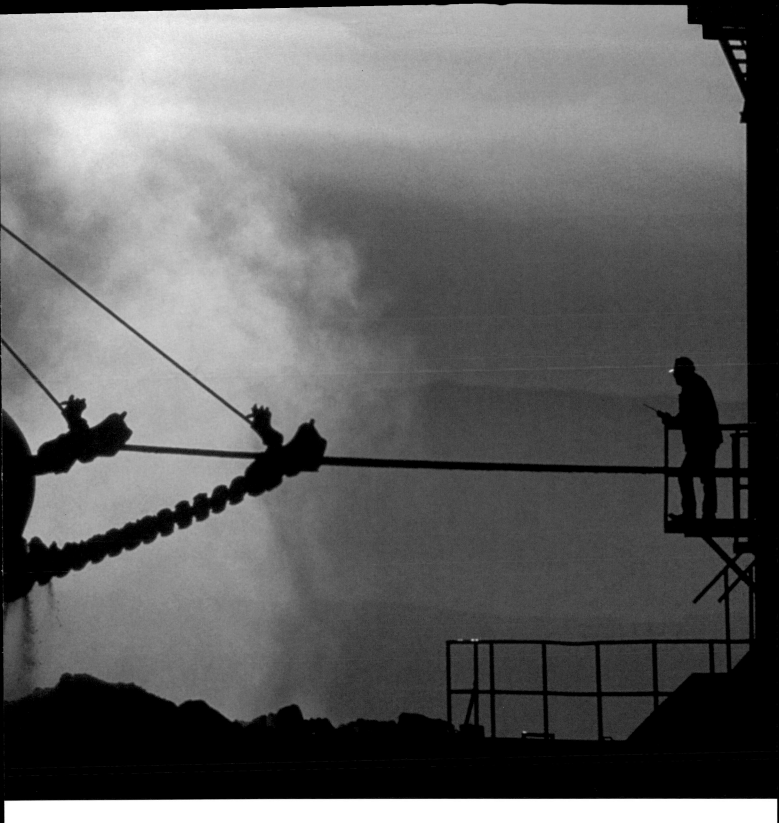

While on assignment for a coal mining company in Montana, I awoke the second morning to welcome clear skies and, in anticipation of the sunrise, positioned myself to photograph the large dragline and its seventy-five-yard shovel against the strong backlight of early morning. The orange light of sunrise was replaced by a yellow-golden light—still warm light, to be sure, but a light that does not imply that the workday is just getting started or is about to end. I asked the safety inspector to stand out on the deck of the machine to add a sense of scale, showing us the enormity of this large machine at work.

Nikon F-3, Nikkor 400mm lens, *f*/16 for 1/500 sec., ISO 100

I will never forget my joy at discovering this sunflower field atop the Valensole plateau in Provence, France, on a very hot summer day in late June 2016. With my camera in manual focus mode, I preset my focus to one meter (or three feet), which rendered a maximum depth of field from fourteen inches to infinity. I'm already looking forward to returning next summer so that I may once again see and photograph these always youthful sunflower fields.

Nikon D810, Nikkor 18–35mm lens at 18mm, *f*/22 for 1/125 sec., ISO 200

OPPOSITE, BOTTOM: After a few seconds of observing this man, whose name is Troy, I approached him and asked if I could make several quick portraits. With my camera in manual mode and my "Who cares?" aperture of *f*/11, I simply adjusted the shutter speed until 1/160 sec. indicated a correct exposure. Then I fired off three shots as Troy sat on this small bench awaiting his order of Cuban coffee. I then wrote down his cell phone number and sent him a copy of the photo you see here.

Whether you know a subject or are approaching a complete stranger, tell your potential subject why you want to photograph him or her and what it is you have in mind. Be honest about your intentions. I can't overstate the importance of this. Most subjects will be happy to help, especially when you promise to send digital copies of the photos you just took before the end of the day (which you won't forget to send, right?).

Nikon D810, Nikkor 24–120mm lens at 85mm, *f*/8 for 1/200 sec., ISO 100

ABOVE: In February 2016, I was in Cape Town, South Africa, when I met Kaye, an employee of Nikon South Africa. Within seconds, I knew I wanted to photograph her. Shortly after our photo walk ended, I found a yellow wall nearby that was the perfect color complement to Kaye's beautiful face and blue eyes. The yellow brings a youthful, energized feel to the overall composition.

Nikon D810, Nikkor 24–120mm lens at 120mm, *f*/6.3 for 1/320 sec., ISO 200

On the streets of Jodhpur, India, time seems to stand still for a young man absorbed in his phone, oblivious to the hustle and bustle around him. The strong overexposed backlight of the setting sun explodes in the background, its golden rays hanging from the vendor's cart like gold chains. To capture this heightened sense of movement, I used a slow 1/6 sec. exposure—with my camera on a tripod, of course! —SUSANA

Nikon D7100, Nikkor 24–85mm lens at 24mm, *f*/11 for 1/6 sec., ISO 100

OPPOSITE, TOP: One spring, while in Holland for a workshop, my students and I were photographing a wonderful dandelion explosion when I asked Olga, a student with bright red hair, to get on the small country road and skip. The other students and I lay down near the edge of the road, using the yellow dandelions as a foreground. In manual focus mode, I preset my focus to one meter (or three feet), directly aligning it with the distance mark on the lens to allow a depth of field of approximately 11 inches to infinity. Olga's playful skipping, coupled with her red hair and the cheerful yellow dandelions—all under the watchful eye of the wise, all-powerful blue sky—exudes a multitude of youthful feelings, announcing that spring had finally arrived.

Nikon D800E, Nikkor 17–35mm lens at 21mm, *f*/22 for 1/200 sec., ISO 400

RIGHT: During my first visit to the Yukon, a fellow photographer I was with came upon a lone dragonfly among a fresh crop of yellow dandelions. It didn't take long for us to make quick work of this composition, since the dragonfly was not going anywhere anytime soon. (Considering the number of mosquitos in the air, we surmised there was an equal number of mosquitos inside its belly. And when a dragonfly's belly is full, it can't go anywhere.) I have purposely shared two compositions here: one with a background of out-of-focus green grass and yellow dandelions, the other with only green grass. The green and yellow background best conveys the late spring season that was well on its way to summer.

You might be surprised to learn that this image was shot with my Nikkor 200-500mm lens—the only one on me at the time—and a 36mm Kenko extension tube. When you place an extension tube between the camera body and lens, the lens is able to focus much closer. The Nikkor 200-500mm is one fine piece of glass that can focus to almost seven feet, but with the aid of the extension tube, I was able to focus to within two feet of the dragonfly. And with the lens fully zoomed out to 500mm, I could easily fill the frame.

Nikon D810, Nikkor 200-500mm lens with 36mm extension tube, ƒ/11 for 1/200 sec., ISO 1000

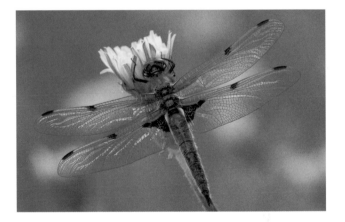

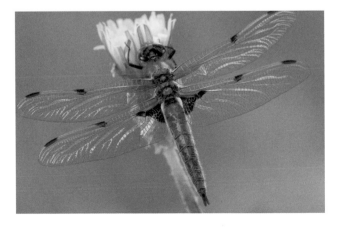

GREEN

Green is forever young. It can never be wise because it never grows up. It is often associated with an inexperienced cowboy who has never roped cattle before, and a *greenhorn* is someone without any experience or who is naïve about a given subject. Green is in a constant state of youthfulness. It is always about hope, fresh starts, and new beginnings.

Green is a cool, recessive color, and its calming effect cannot be overstated, which is why I often look for out-of-focus green backgrounds whenever I'm shooting portraits. Children and family photographers often photograph their subjects in local parks, where green backgrounds are plentiful. Green backgrounds soften the subjects, call attention to their youth, and suggest hope and a fresh start. Even the temperament of the local "sourpuss" can be softened when composed against an out-of-focus green background. If you are filling the frame with green midtones, set an exposure of −2/3 to produce the best color.

In the process of writing this book, it quickly became apparent to me that I do not have an extensive collection of green images. This was not all that surprising. In my entire wardrobe, not a single green item can be found. If there is a weakness in my color vision, it is certainly the color green. How ironic is it that I now live in the Pacific Northwest, where evergreen trees and shrubs abound at every turn? It's fair to say that in the coming months I will be, at times unwillingly, adding more green to my photographic collection.

The color complement to green is red.

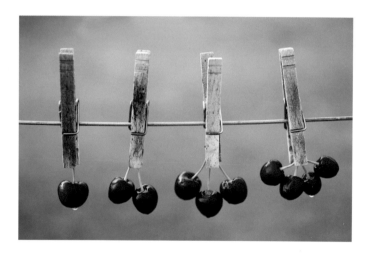

One day in early June, I decided to hang two loads of laundry outside to dry in the warm fresh breeze. As I did so, an idea occurred to me: why not hang cherries out to dry? Since our nearby cherry tree was bursting with fruit, it took little effort to gather a few, hang them up, and give them a quick shot of water with the fan sprayer attached to the garden hose.

I deliberately sought out a lone cherry, then two attached to the same stem, then three, and finally four.

Crazy as it sounds, it was my way of celebrating life as a mother, and how our family has grown with each of our four children.

By combining a large lens opening with my telephoto zoom, I reduced the large backyard lawn to an out-of-focus green, the color complement to the red cherries. —SUSANA

Canon 1D Mark II, Canon 70–200mm lens at 200mm, *f*/4 for 1/500 sec., ISO 100

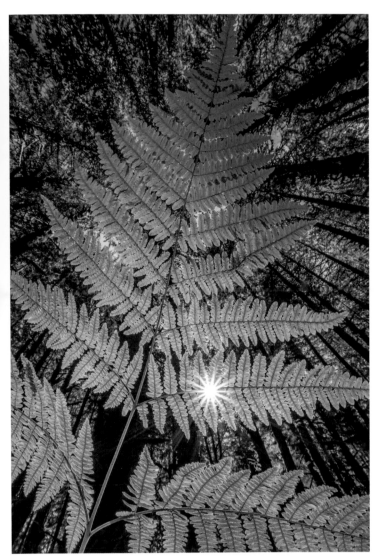

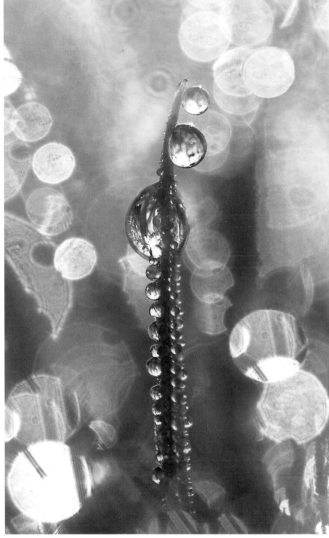

Curiosity? I can't imagine my photographic life without it. In this instance, a simple stirring from the ground below caught my attention. Was it a mouse? And if so, was it looking up at me? How would the world look, anyway, through the eyes of a mouse? It was then that I noticed a large fern growing out of the ground nearby. Did this fern provide cover for the mouse during the frequent rain here in Washington's Hoh Rainforest? I soon found myself lying on the forest floor looking straight up to the fern and beyond. A mouse's point of view, perhaps? I chose a composition that allowed a piece of the sun's light to "starburst" through the backlit fern. Curiosity can be rewarding.

Nikon D810, Nikkor 18–35mm lens, *f*/22 for 1/60 sec., ISO 200

When you combine a macro lens with a focal length of 40–80mm and a 25mm or 36mm extension tube, you will be able to compose close-ups that are larger than life-sized. This is important to note because now when you focus on a single dew-laden blade of grass, you'll discover that each dewdrop is like a tiny fish-eye lens, recording the surrounding landscape. You'll also notice the "jewels" created by out-of-focus dewdrops in front of and behind the blade you are focusing on. I took this image one morning in Iowa. Resting my camera firmly on a small beanbag for support, I scooted inch by inch, left and right, from one blade of grass to the next. To get maximum sharpness, I used apertures ranging from *f*/11 to *f*/16 and kept the camera and lens parallel to each blade. The image's mood of "new beginnings" is all due to the power of green.

Nikon D800E, Micro Nikkor lens, *f*/13 for 1/80 sec., ISO 200

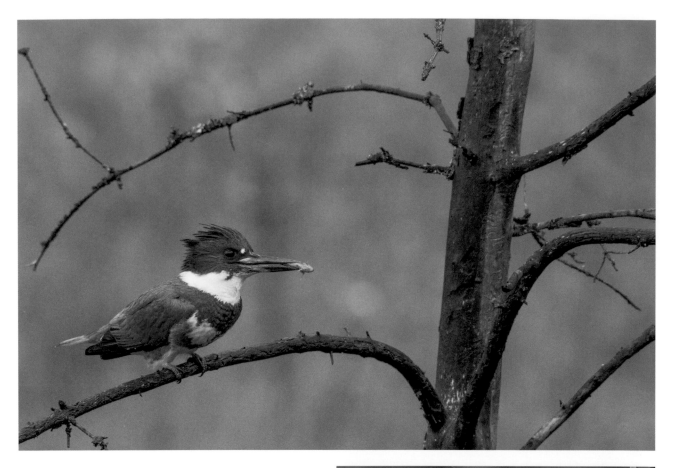

One lazy Friday afternoon, I found myself parked on the side of the road at a place called Fish Lake, just outside the town of Whitehorse in the Yukon territory of Canada. A belted kingfisher with a small fish in its mouth flew up from the stream below, landing in a tree. Fortunately, I had my Nikon D810 camera, Nikkor 200–500mm lens, and Nikkor TC1.7 teleconverter with me, all attached to my monopod. The 1.7 teleconverter turned my 200–500mm lens into a 340–850mm lens.

I hurriedly framed up the kingfisher and fired off five shots, but noticed that a branch was merging with the bird's beak. As I waited for the Kingfisher to turn its head and eliminate the merge, it flew to an even closer tree, with a more vibrant green background. I was now able to capture cleaner compositions of the gray-blue bird against the youthful green background.

In my excitement, I took more than twenty shots, one of which you see here, shot around the 700mm focal length at ƒ/13 for 1/640 sec. Since it was late in the day and I was in open shade, I used an ISO of 3200, which on the D810 is still clean of major "noise."

Both images: Nikon D810, Nikkor 200–500mm lens with a TC1.7 teleconverter, ƒ/13 for 1/640 sec., ISO 3200

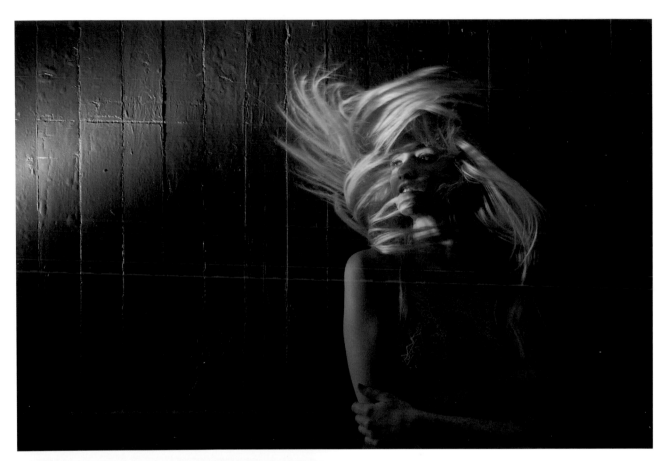

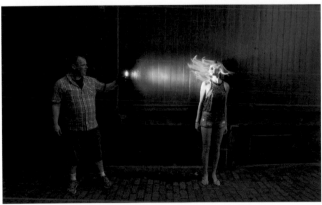

When great light is absent, an alternative can often be found inside many photographers' camera bags: the portable electronic flash.

In the image above, I had a student, Andrew, hold the flash, and with the aid of Nikon's Commander mode, I was able to fire it remotely. I directed my student-turned-model, Emily, to turn away from the flash and, on the count of three, quickly turn back toward it, making her hair "fly."

It's important to note that when using your flash, you operate your camera in manual exposure mode. This way, you always have full control over the ambient light. More specifically, you can choose to either include the ambient light with the flash exposure, or "kill" it by setting a 3- to 4-stop underexposure for the ambient light.

I set the camera to my "Who cares?" aperture of $f/11$, then adjusted my shutter speed until 1/8 sec. indicated a correct exposure for the ambient light. I also wanted to kill the ambient light, something that requires a minimum of four stops of underexposure. A general rule of thumb is to start by setting your shutter speed to 1/200 sec. This is often enough to kill the ambient light, and also stays inside the fastest "flash sync shutter speed" permissible with both Nikon and Canon. In this case, starting with my correct 1/8 sec. exposure, 1/200 sec. is 4-2/3 stops underexposed (1/8 sec. to 1/15 sec., to 1/30 sec., to 1/60 sec., to 1/125 sec., to 1/200 sec.), enough to kill the ambient light.

With my flash set in TTL mode, it will fire a flash exposure based on my aperture choice of $f/11$. Because I'm at $f/11$ at 1/200 sec., the only light recorded by the sensor is the light from the flash.

That green wall was perfect, allowing Emily to be the star of the show. It is also important to note that I used an amber-colored gel on the flash. This accounts for the warm light on the wall and on Emily.

Nikon D800E, Nikkor 24–120mm lens at 50mm, $f/11$ for 1/200 sec., ISO 100, Nikon SB-900 flash in TTL mode

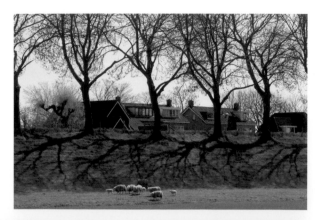

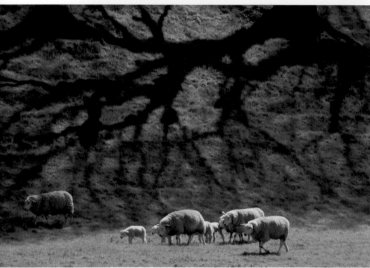

These roaming sheep in Holland presented the opportunity to frame a mostly green composition while also incorporating the root-like shapes on the hillside behind them. Granted, these are obviously not tree roots but shadows cast down on the hillside from branches overhead. As my daughter was quick to point out, it felt very Harry Potter–like.

More often than not, it is the telephoto lens that allows one to shoot very clean compositions. Its narrow angle of view enables us to make smaller selections from chaotic landscapes and cityscapes. For this shot, I called upon my Nikkor 18–300mm lens. When combined with my Nikon D7200, it offers an effective focal length of up to 450mm. That very narrow angle of view allowed me to extract just the sheep and hillside, resulting in a cleaner composition without distractions from the sky or the houses along the dike.

Nikon D7200, Nikkor 18–300mm lens, *f*/16 for 1/160 sec., ISO 200

The once-sleepy region of northeastern Washington State, known as the Palouse region, has become a hotbed of tours and photography workshops. Thanks to its wide-open spaces, rolling hills of farmland, deep blue skies, and puffy white clouds, it's easy to understand why photographers love it. It was back in 1989 when I recorded this image of rolling fields of wheat interrupted by the occasional farmhouse or, in this case, grain elevator.

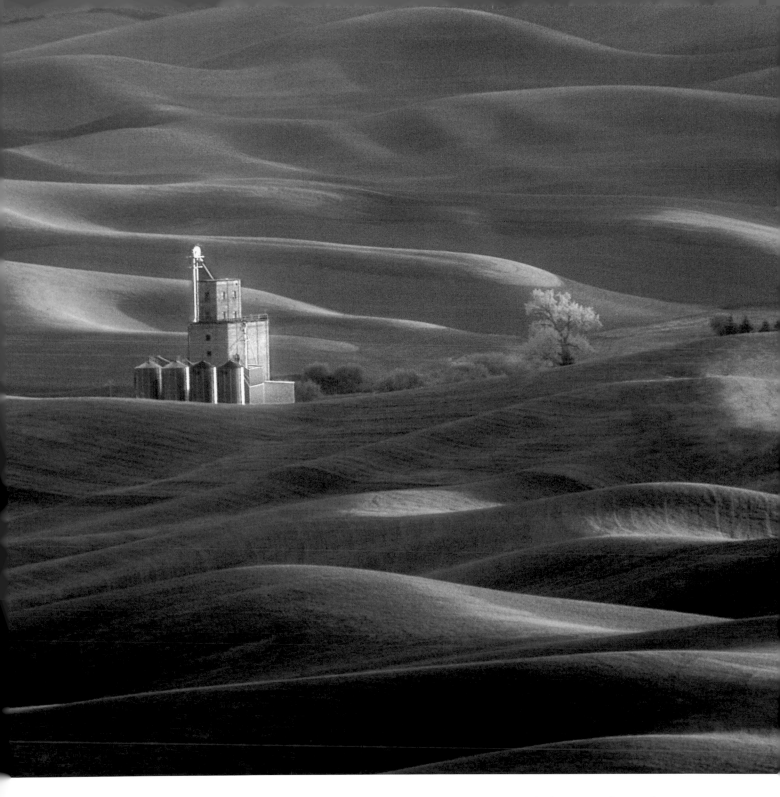

I returned to the Palouse in 2015, and this same view still exists today.

Almost everyone I show this image to describes it as soothing, not only because of the color green but also for the curvilinear lines. A curvilinear line is often associated with the hand of God, wind, or a meandering and babbling brook, and of course the human body. They're also associated with passivity because of their wandering, somewhat slow yet deliberate nature.

To capture this shot, I pulled over near the top of Steptoe Butte and mounted my camera and 200–400mm lens. With my aperture set to $f/22$ for deep depth of field, I adjusted my shutter speed until 1/125 sec. indicated a –2/3 underexposure to record an accurate green.

Nikon D800E, Nikkor 200–400mm lens at 400mm, $f/22$ for 1/80 sec., ISO 200

BLUE

More than two-thirds of the earth and one hundred percent of the sky is covered with blue, so is it surprising that it's such a well-liked color? As of this writing, blue is the most popular color worldwide, followed by purple, then red and green. (And which do you suppose was the least favorite? White!)

Blue is considered the most stable and reliable color, as well as the sincerest. Blue is also restful; it promotes peace and tranquility. Lying on your back on the warm sand or green grass and looking up at a blue sky is relaxing no matter what the season. Even in the cold of winter, looking up at a blue sky has a calming effect on all of us. For some, blue is a spiritual color. In American culture, blue also has strong connotations of depression, as in "singing the blues."

There are, of course, many shades of blue: steel blue, navy blue, royal blue, sky blue, and baby blue, just to name a few. And, of all colors, blue has the most varied and complex meanings depending on the particular shade. Dark blue is associated with authority, trust, intelligence, and dignity. Bright blue projects dependability, coolness, cleanliness, and strength. Light blue evokes serenity and peace.

Blue is recessive; it stays in the background. Blue does not crowd us or suffocate us. It gives us the space to feel free, to run, to dance, to jump in a field of yellow dandelions under the vastness of its outstretched arms. If you are filling the frame with navy blue, set your exposure to –1; if blue midtones, try –2/3.

The color complement to blue is orange.

Santorini is considered one of the most beautiful of the Greek islands, and no wonder. You've got to love those cliffside towns with their narrow alleyways and donkeys carrying goods up and down the steep cliffs. And where would these islands be without their cats? I followed this cat for some five minutes until he finally found a resting place at the top of some colorful steps. I moved to a short wall to the left, getting into position to shoot down and at an angle to the stairs. All that remained was for the cat to run down the steps, but he seemed rather content to sit.

He was just lying down to take a nap when a barking dog was heard coming our way—and off he went. Handholding my camera and 17–55mm lens, with the ISO set to 100 and my shutter speed to 1/500 sec., and since I had already adjusted the aperture in anticipation of the shot, I was ready.

Nikon D300, Nikkor 17–55mm lens, *f*/8 for 1/500 sec., ISO 100

Just like the migratory birds who fly south for the winter, I, too, have an annual migration that finds me flying south to Cancun every August. I seldom get much shooting done there, as my ideal vacation includes a break from my camera, but on one such trip, the Caribbean put on such a show of color that I could no longer resist. The tones and shades of blue were quite distinct from foreground to background. But it wasn't until thirty minutes later that I spotted a large sailboat coming in from the right. As you can see, the contrast of the white boat against all that blue is what makes the image.

Nikon D300S, Nikkor 70-300mm lens at 300mm, *f*/22 for 1/100 sec., ISO 200

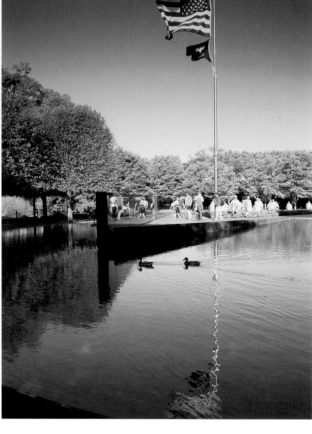

Here, a lone mallard takes a relaxing dip in the small reflecting pool at the Korean War Memorial in Washington, DC. Because it's a recessive color, the blue gives the image a great sense of depth. Notice also how the tones of blue, from dark to light, create a sense of distance, the darker blue conveying a farther deepness while the lighter blue brings a closer, more playful note.

Nikon D800E, Nikkor 24–120mm lens at 80mm, f/16 for 1/125 sec., ISO 200

LEFT: Have you ever run through a field under a vast blue sky on a warm summer day or flown a kite from atop a hill under the deep blue of an autumn sky? In West Friesland, Holland, tulip fields abound during the month of April. If you hang around for two or three days, you can record countless compositions of the tulips beneath these famous Flemish blue skies filled with varying shapes of white clouds.

Nikon D810, Nikkor 16–35mm lens at 16mm, f/11 for 1/200 sec., ISO 100

The Eiffel Tower is one of the most photographed monuments in the world; it is nearly impossible to come up with a fresh approach or never-before-seen perspective. In this case, Bryan and I found ourselves on an avenue near the base of the Eiffel Tower during the blue hour (twilight), and since we didn't see any other photographers, we could at least pretend we were doing something original and unique.

With my camera and lens mounted on a tripod, I set the aperture to f/22 to take advantage of the "starburst" phenomena, which is created by using this smallest of apertures with a long exposure and a composition of city lights, such as the streetlights you see here. I centered the tripod in the avenue to capture a sweeping yet symmetrical composition with the wide angle of my full-frame fish-eye lens. —SUSANA

Nikon D7100, Nikkor 14mm fish-eye lens, f/22 for 15 seconds, ISO 100

Sometimes dramatic turns in life take us to places and people we could have never imagined. That's how I ended up in the Bajo Circuito concert venue near Mexico City. Six months earlier, my daughter had sent an audition tape to producers of *The Voice Mexico*. Now we were here, my daughter in the dressing room preparing to perform a duet with her boyfriend.

The tunnel entrance of the venue was still empty, doors not yet opened to the concert guests outside. In that still moment—between the hustle-bustle of the production crew fine-tuning final details and the doors opening to the public—I found myself reflecting on the people who have remained close to me at all times, no matter what life has thrown my way. I convinced my other daughter to give me a few minutes of her time to capture that pensive feeling. Obviously, color is not the only factor lending this image a darker mood. The direction of the light also creates drama, heightened by the tunnel-like location and alternating dark and light blue lines leading toward the subject. As I pressed the shutter release, I knew this would be one of the most memorable "blues" images I would ever make. —SUSANA

Nikon D810, Nikkor 24–120mm lens, ƒ/4.5 for 1/80 sec., ISO 3200

I'm continually amazed by the lack of noise when shooting at ISO 3200 in low light with my Nikon D800E. After spending the afternoon atop the hill in the center of San Miguel, Mexico, I began the short walk down to my hotel when I came upon this father and his two sons enjoying dinner in a small restaurant. I stood across the street, handholding my camera and Nikkor 24–120mm lens as a woman passed by, I waited for her to clear the window before pressing

the shutter, and the 1/20 sec. exposure rendered her brisk stride as a ghosted blur, adding welcome contrast to the sharply defined family through the window. As an added bonus, the colors of her purse mimic those of the art hanging in the restaurant: pure luck.

Nikon D800E, Nikkor 24–120mm lens, f/16 for 1/20 sec., ISO 3200, Tungsten/Incandescent white balance

Like many photographers, I love the "blue hour," that time just before dawn or after sunset, particularly when shooting in cities. The mood of the blue hour, not surprisingly, is a bit soulful, like a final good-bye after an enjoyable day, but it is also one of mystery and suspense, since the final colorful light will soon be replaced with darkness. To capture this blue-hour shot of Amsterdam, I deliberately began my fifteen-second exposure knowing that an oncoming dinner-cruise boat would pass through. I wanted the boat's lights to record as mysterious streaks through the composition. Why don't we see the boat, other than its lights? Because the boat was a bit too dark and was moving far too quickly to record an exposure.

Nikon D810, Nikkor 24–120mm lens at 24mm, f/22 for 15 seconds, ISO 100

It wasn't until fall 2015 that I visited Vancouver Island in British Columbia for the first time. I know, I know, what took me so long? On this particular late afternoon, the tide was on its way out, leaving behind large puddles of saltwater—puddles that serve as "mirroring opportunities" if one is willing to lie down at their edge with a wide-angle lens. By doing so, you will always increase the volume of your photograph, like going from AM radio to FM stereo.

I took up my position at the edge of this large pool and waited for things to unfold, shooting at will over the next ten minutes. In the exposure you see here, a lone surfer had just thrown a small ball out ahead of his dog. The steely blue that makes up so much of this photograph is in part due to my Daylight white balance choice, which is right around 4800 K. When it's late in the day and the sky is filled with clouds, you can deliberately underexpose the clouds to record these gunmetal, steely-blue tones.

Nikon D810, Nikkor 17–35mm lens, *f*/22 for 1/160 sec., ISO 200

PURPLE

Purple (violet) is a secondary color, derived from a mixture of red and blue. Though generally a receding color, purple speaks much the same language as red with just whispers from blue.

Purple is highly associated with royalty, especially the riches of the Byzantine era (ca. 330–1453). If a king and queen wore purple, it was a clear statement of their wealth. Why this strong association? During the Phoenician era (1500–300 BC), more than 250,000 of a particular snail had to be harvested to make one ounce of the color purple. After cracking open the shell of each snail, a deep purple phlegm-like material was extracted and left in the sun to dry. Let's do the math. How many snails were needed to create one pound of purple dye? It's a staggering four million snails, give or take a thousand. It has been estimated that one pound of dyed purple wool cost more to make than the entire annual salary of a common laborer. A similar process was used by the Aztecs (ca. 1345–1521) to make red dye, crushing millions of red cochineal bugs and letting their red juices dry in the sun to leave a powdery residue. Needless to say, anyone wearing purple clothing was assumed to be a member of the royal family.

Purple continued its long reign as the calling card of the rich until synthetic purple dyes came along in the mid-1800s, when these cheaper dyes quickly replaced the more expensive ones, since it was impossible to tell them apart.

The color purple is symbolic of leadership, spirituality, and individualism. It is considered magical and mysterious. While some report finding the color purple soothing, others report that large amounts of purple (an entire room, for example) creates anxiety.

Have you noticed how purple is one of the most elusive colors in nature? It's true that purple and magenta hues are often seen following sunset or in the predawn light of the sky, but purple flowers and especially purple fruit and purple vegetables are in short supply compared to those of other colors.

If you are filling the frame with deep purple, set your exposure to −1. The color complement to purple is yellow.

OPPOSITE: It was about twenty minutes after sunset when the sky over the Sheikh Zayed Mosque in the emirate of Abu Dhabi began serving up a vivid dose of purple and magenta. Because I was set up at the base of a nearby reflecting pond, I was able to turn up the volume of this colorful composition by including my subject's reflection, a helpful technique when shooting landscapes near wet sand, large puddles, or lakes.

Nikon D800E, Nikkor 17–35mm lens at 19mm, *f*/22 for 4 seconds, ISO 100, tripod

ABOVE: Inside the greenhouses of the Keukenhof, Holland's large national park, you can find hundreds of tulips in all shades and colors on display for public enjoyment. I hung around an area where various shades of purple tulips were growing and asked visitors which of the following words best described what they saw: "beautiful," "elegant," "rich," "pretty," "vibrant," "regal," or "gorgeous." Sure enough, "regal" was the top answer, with "rich" at number two. Here, I've combined four macro shots of different purple tulips for a "regal" composition.

All images: Nikon D810, Nikkor 105mm micro lens, *f*/16 for 1/100 sec., ISO 400

ABOVE: I seldom have difficulty finding photographers who are willing to venture out at sunset and then keep shooting for another thirty minutes afterward. But if I suggest they head out to shoot an hour before sunrise instead, I am met with loud groans. Regardless, this is exactly what my students and I did one October morning at Beverly Beach, along the Oregon coast. And as my students remarked over breakfast afterward, they had no idea the predawn light could be so colorful. I've said it before and I'll say it again: sleep is overrated!

Nikon D-810, Nikkor 24–120mm lens at 50mm, *f*/22 for 1/8 sec., ISO 100, tripod

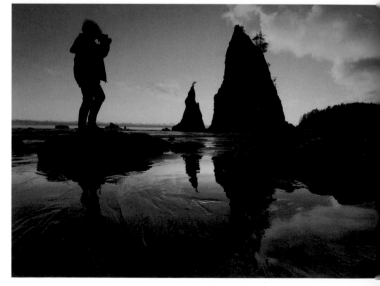

OPPOSITE, BOTTOM: Sunsets, as most of us know, are often unpredictable, and this one at Rialto Beach in Washington State was no exception. The skies were clear when we arrived, hours before sunset, but over the course of that last hour clouds started rolling in. Lucky us, as the clouds offered welcome color and contrast against the blue sky.

Nikon D810, Nikkor 18–35mm lens at 18mm, f/22 for 1/30 sec., ISO 200

ABOVE: One late afternoon atop the Valensole plateau in southern France, the white puffy clouds were engaged in a game of tag with the sun. This can be a landscape photographer's dream; if one is patient, the coming and going of shadow and light across the landscape can create truly compelling pockets of light. Although it was brief, this is exactly what took place. I hollered to the students to get ready, and within seconds the dance of light and dark unfolded before us. I fired off ten to fifteen frames in rapid succession—and then it was over.

Nikon D810, Nikkor 200–500mm lens with polarizing filter, f/13 for 1/320 sec., ISO 640, monopod

Located near the base of the Space Needle in Seattle, Washington, is the Museum of Pop Culture. Designed by architect Frank O. Gehry, the outer shell of the museum is made up of 21,000 sheets of stainless steel and painted aluminum. Depending on the light, this metal reflects shades of both purple and magenta. On this day, the varying shades of purple created a *regal* backdrop to my leaping student-turned-model, a linguistics major from Purdue University named Aya Ikoda.

Nikon D800E, Nikkor 24–120mm lens, *f*/8 for 1/1000 sec., ISO 200

LEFT: The United Arab Emirates is no stranger to royalty and riches, and Dubai is a magical, elegant, opulent, stylish city. Fortunately for me, a passing afternoon storm of rain and wind was clearing out just as the sun was setting. About twenty minutes after sunset, the colors of this amazing light show had reached their peak. With my camera and 24–120mm lens mounted on a tripod, I shot several 8-second exposures of the Dubai skyline from the rooftop pool area of the Park Regis Kris Kin Hotel.

Nikon D810, Nikkor 24–120mm lens, *f*/11 for 8 seconds, ISO 200

WHITE

Green may be the symbol of hope, but if you are looking for the ultimate of all hopes, you will find it in the color white. Not only hope, but new beginnings, and, of course, profound faith. Christian paintings almost without fail show Jesus in a white robe, or depict the white-robed hand of God coming through white clouds while baby Jesus wears a small white gown. Throughout most of the world, white is all about faith, hope, and purity. White is associated with goodness and righteousness, while black is evil and bad. White helps us feel safe and relaxed.

White robes are worn by men of the Islamic faith, and a white wedding dress continues to be the choice of many brides. Some cultures also wear white during periods of mourning and at funerals. A fresh snowfall makes everything look clean, and white walls, floors, ceilings, and countertops convey the cleanliness of medical facilities around the world.

White is an advancing color, used for waving flags of surrender in wartime. In terms of visual weight, it is, of course, light. When you are filling the frame with white, always set at least +1 exposure.

White has a voracious appetite; when the Rainbow Delivery van came knocking, white ate nothing! In other words, white results from the reflection of all light wave colors. The opposite of white, in the sense that it absorbs all light wave colors, is black.

While walking along the streets of Savannah, Georgia, my eyes caught sight of these two white wooden chairs. I immediately imagined two wise elderly people sitting in them, sharing their wisdom with whomever stopped by. Such is the power of white.

Nikon F-5, Nikkor 35–70mm lens, *f*/22 for 1/60 sec., ISO 100

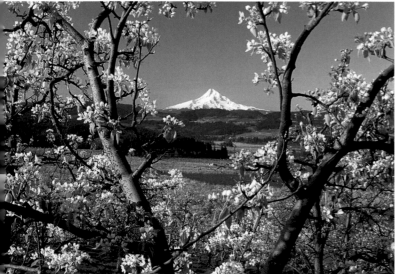

The Sheikh Zayed Mosque in the Emirate of Abu Dhabi (also shown on page 110) is white on the inside, with gold details everywhere. All of this white speaks to the Muslim (and Christian) association of the color white with spirituality.

This composition is one of those right-place, right-time images. As soon as I set up my tripod and camera to shoot this long hallway, a lone young woman appeared out of nowhere, her black burqa standing in marked contrast to the white and giving the overall composition a welcome sense of scale. —SUSANA

Nikon D7100, Nikkor 70–300mm lens, ƒ/11 for 1/320 sec., ISO 200

LEFT: In the area around Hood River, Oregon, snow-white apple blossoms are the order of the day for about two weeks every April. I had been invited by a local farmer to come onto his property, and he loaned me a ladder so I could set up to get the composition you see here. It could not have been better: early-morning light, clear skies, and a wonderful view of distant Mt. Hood. The purity of this photograph—described by many as "heavenly"—is one hundred percent the result of the dominating color white.

Nikon FE, Nikkor 105mm lens, ƒ/32 for 1/30 sec., ISO 50

Perhaps because white is so pure, it is also the easiest color to contaminate. Knowing this, I took a white rose and set it next to a small multicolored lightbulb. Just like that, the sensual, soft colors from the lightbulb replaced the original white. —SUSANA

Canon 1D MarkII, Canon 50mm macro lens, f/5.6 for 1/200 sec., ISO 320

BLACK

The color black is considered by many to be a slimming color. When you wear black, you immediately shed some of those unwanted pounds. This slimming illusion is entirely attributable to our *inability* to see black. Black is more recessive than any color. It is the absence of color. Without color, it is hard to see detail. And since black absorbs about 90 percent of light, it is also difficult to see form and texture, both elements of design that give clues to a subject's volume. (By the way, I would be remiss in my exploration of fashion and color if I did not tell you what colors make you look fatter: red and yellow, particularly when worn in horizontal stripes. Red and yellow are the most advancing colors. They

reach out beyond themselves, and as a result, you look wider and heavier than you actually are.) When photographing something black, set your exposure to −1.

Black is mysterious and serious, elegant and sophisticated. Black is powerful, dangerous, and evil, portrayed in the movies by black suits, black cars, and the black market. Black is also loss and depression. It is Black Monday, it is grief, it is death. In most Western cultures, black is funereal, the color of mourning.

Black complements *any* color, and it adds contrast to every color. Black is the audience that gives applause to whatever color is onstage.

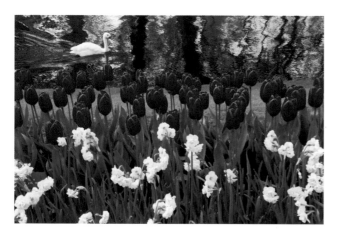

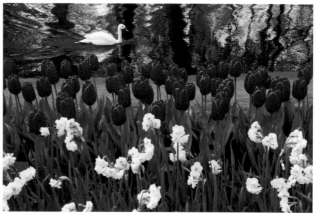

This image of the Keukenhof flower park in Lisse, Holland, shot in late April 2016, succeeds due to the color black. If you are asking yourself, "What black?" note the position of the swan. When it entered the scene, I deliberately waited for its neck and head to move in front of the black reflection of trees on the surface of the water. This created the necessary contrast for the swan's white neck and head to

stand out from the otherwise white-gray water. Compare this to the other example, taken just before the swan reached the black reflections. Subtle as it might be, the white head and neck get lost in the white-gray of the water.

Both images: Nikon D810, Nikkor 24–120mm lens at 70mm, *f*/22 for 1/100 sec., ISO 1000

Black plays such an important in role in the realm of contrast. Ever notice how jewelry stores display diamonds on black velvet cloths? Those diamonds look brighter and even bigger against black. Black is deep space, depth, and as a result it elevates all other colors that sit on top of it.

Here is an example of what happens when you place pure white on top of black. This large daisy is in full sun, but is against a background of open shade. I set my exposure for the sunlit daisy, *not* the much darker open shade, to record a black "velvet" background.

Nikon D7200, Nikkor 18–300mm lens, *f*/11 for 1/400 sec., ISO 200

Another technique that makes the most of black is to shoot backlit scenes and expose for the brighter backgrounds, turning the darker foreground shapes into silhouettes. For this image—shot on a July evening in Provence, France—I exposed for the brighter sunset, recording the darker tree in front as a graceful silhouette, all the while standing at the base of the tree—a "selfie" of sorts.

Afterward, I sat on the ground between rows of scented lavender, reminiscing about a similarly lone tree from forty years prior, when I'd first dreamed of becoming a professional photographer. I'd pulled off the road to photograph the tree, which stood in a farmer's field in Oregon's Willamette Valley, and the farmer had spotted me and waved me over. In our subsequent chat, I asked why he had left the one large oak tree in his field, and his response has stayed with me ever since. He said that it served as a daily reminder: when hardships come along, you must stand your ground, never give up, always give it your all. Suddenly I realized that over time, I had become that oak. So, to all of you aspiring photographers, give it your all and never give up!

Nikon D810, Nikkor 24–120mm lens at 35mm, *f*/16 for 1 second, ISO 1000

Most Americans are familiar with Zorro and the Lone Ranger. Although the masks they wore were black, a color normally associated with evil, they were actually the good guys. Likewise, in my world travels I have come across my share of "masked" women, primarily in the Middle East. And just like Zorro and the Lone Ranger, they, too, are good. This misconception that masked persons are somehow evil and sinister is of course not true. If there is one piece of non-photographic advice I would love to share, it is to reach across the fence before assuming that strangers are "evil." Chances are, they probably share many of the same desires, hopes, and dreams that you do.

Nikon D300S, Micro Nikkor 105mm lens, *f*/8 for 1/125 sec., ISO 200

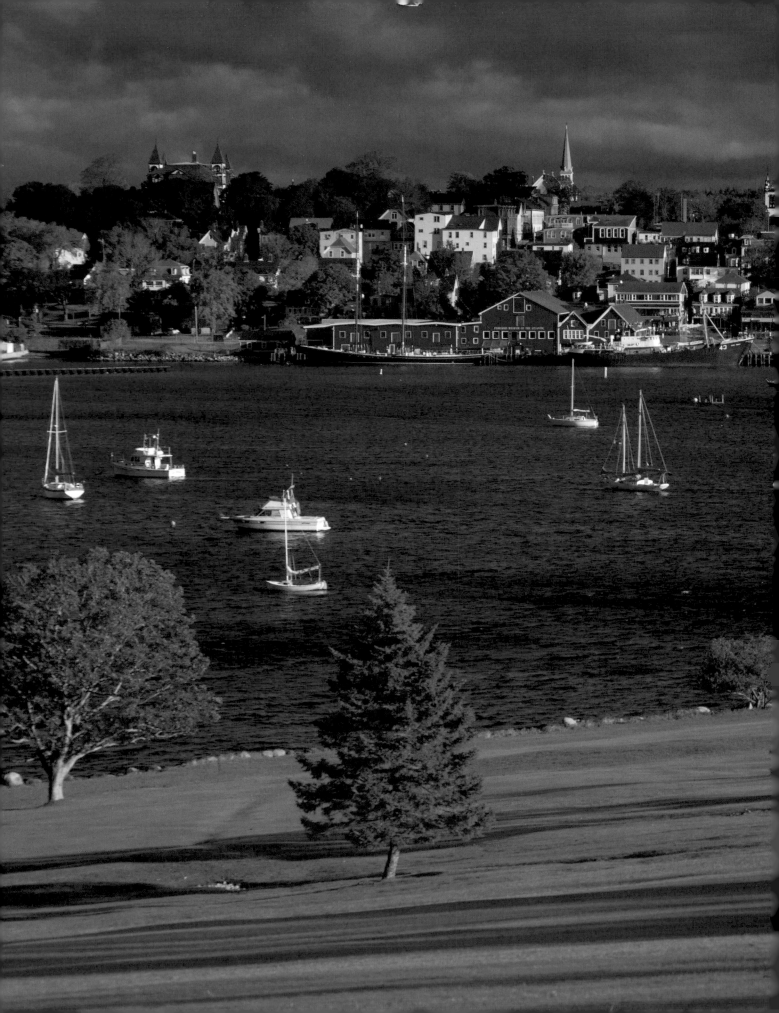

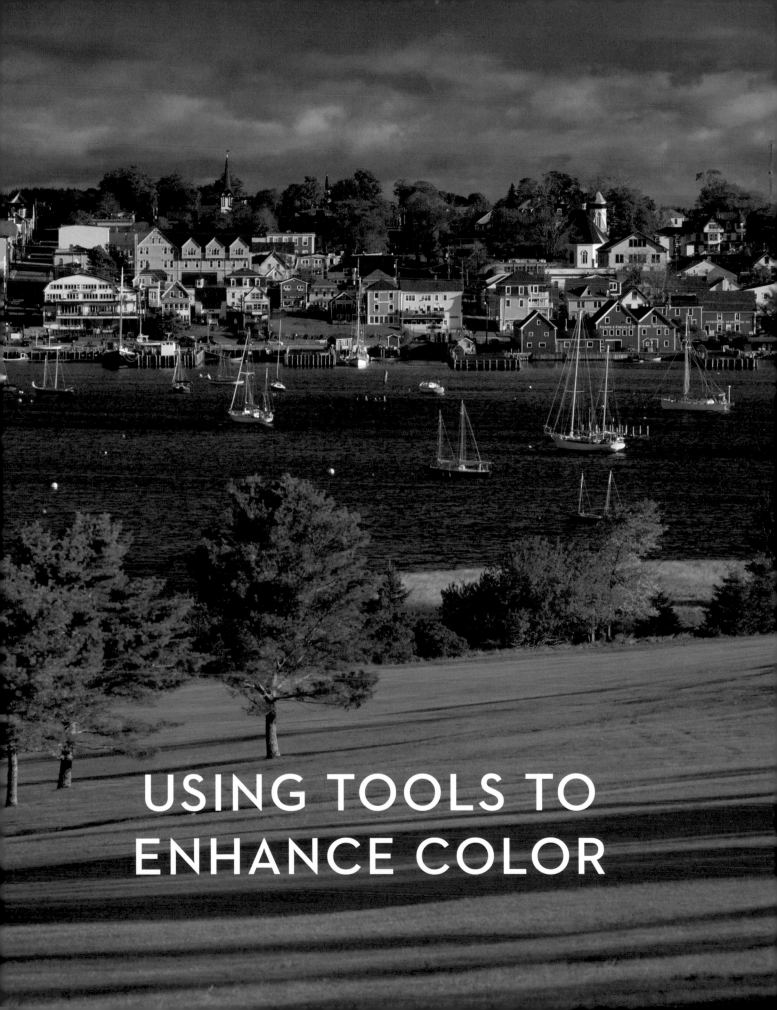

USING TOOLS TO
ENHANCE COLOR

FILTERS

If you know me from my previous books, you already know I am a big fan of natural light and natural color. I was never a fan of overreliance on colored filters back in the film days, and that same aversion holds true today. That said, I always have *two* filters at the ready, should I feel they are necessary: a magenta FLW filter and a Lee graduated tobacco-colored filter.

I use the magenta filter at sunrise and sunset when shooting backlit scenes, as well as when shooting city skylines at dusk. When used with skylines at dusk, the filter removes the unwanted green cast caused by the fluorescent lighting in many offices within the skyline. The filter's magenta color also mixes well with the dusky blue sky, rendering some truly vivid color. To be clear, I do not advocate using orange or red filters at sunrise or sunset as they can be overbearing; the magenta filter is much subtler, imparting just a touch more overall color.

When I find that the sky is drab, or when it promises to be an unspectacular sunset or sunrise, I sometimes call upon my Lee Tobacco Graduated color filter. This is a filter that I hold in front of my lens. Only the top portion of the filter is tobacco colored, allowing me to add color to the sky without affecting the color of the landscape below.

In addition, of course, I use a polarizing filter with great fervor whenever I am at a ninety-degree angle to the sun, since it reduces, if not eliminates, the gray glare that often flattens or dulls a subject's color. More often than not, it is the polarizing filter that is responsible for producing vibrant blue skies when shooting sidelit scenes.

I have been shooting the Singapore skyline from the balcony of my room at the Swissôtel for a number of years. It should be immediately clear which of these two images benefitted from the use of the magenta FLW filter. The one with the greenish cast is, of course, the one shot *without* the filter.

Left: Nikon D810, Nikkor 24–120mm lens, *f*/11 for 8 seconds, ISO 100; below: Nikon D810, Nikkor 24–120mm lens, *f*/11 for 8 seconds with magenta FLW filter, ISO 100

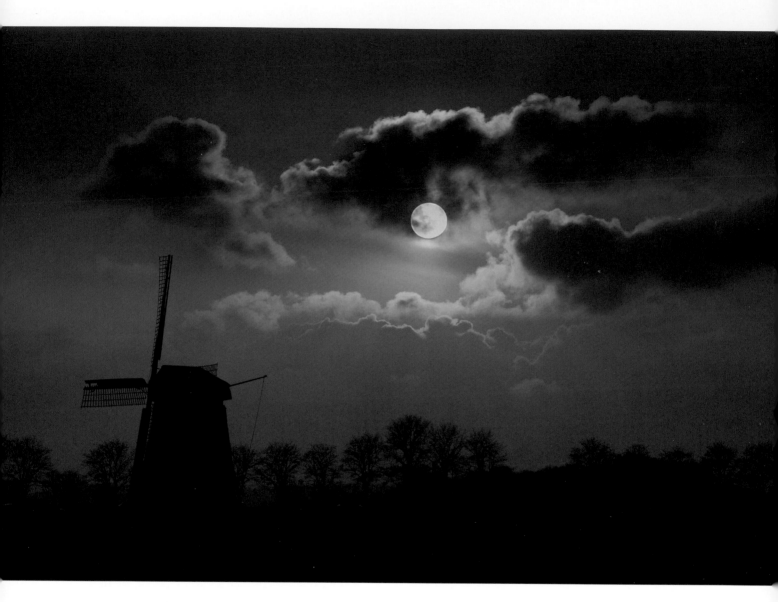

It was apparent that this sunset was going to be a dud as clouds were moving in quickly and would soon obscure all of the remaining light, so I decided to hurry things along. With the sun still visible, I placed the Lee graduated tobacco-colored filter in front of my lens, turning an otherwise flat and lifeless landscape into something memorable.

Nikon D300S, Nikkor 70–300mm lens with Lee graduated tobacco-colored filter, f/16 for 1/320 sec., ISO 200

OPPOSITE: If you find yourself out shooting at midday—normally a time of day when the light is harsh—a polarizing filter will severely reduce surface glare, rendering a much more vivid blue sky. In addition to the polarizing filter here, I also used a Lee 2-stop graduated neutral-density filter. I wanted to not only bring up more blue in the sky but also kick up the contrast a bit, making the sky in the second image a bit underexposed.

Top: Nikon D810, Nikkor 24–120mm lens, f/16 for 1/200 sec., ISO 200; bottom: Nikon D810, Nikkor 24–120mm lens with polarizing filter and Lee 2-stop graduated ND filter, f/16 for 1/60 sec., ISO 200

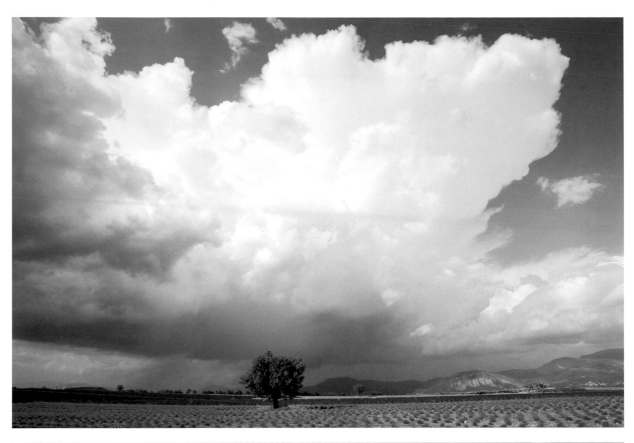

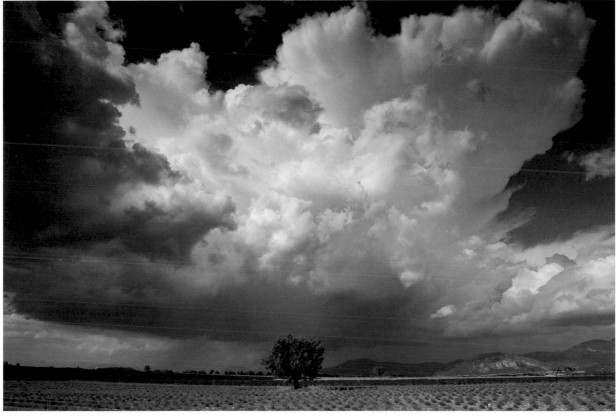

PHOTOSHOP

It is no secret that I am not a fan of the, at times, very lengthy exercise of postprocessing images. This has nothing to do with ignorance, as I am well versed in the subject. The reason I believe so strongly in getting my composition and exposure done in-camera is simple: because I *can*, and so can you! And as long as we both can, why would we wish to spend additional time working on our images?

As I see it, the intent of software such as Photoshop and Lightroom is to *extend* your vision, to add a few more tricks to the already magical light show that you perform *in-camera*. After all, it is *your* brain that is doing the creative problem-solving, and *your* finger that is pressing the shutter release. Your goal is to freeze a moment in time; a decisive moment that captures the evidence that you got up early, or stayed out late, that you used the right lens, chose the perfect combination of aperture and shutter speed, and created a compelling composition. There are so many ways to stay in the driver's seat of this creative process called image-making: shift your point of view just an inch, or several feet, or even miles; shoot from above, below, through, or from behind; shoot in the morning light, in the late afternoon light, at dusk, in the spring, summer, fall, or winter; return to the same scene at different times of the day or week or under various weather conditions.

My time spent in postprocessing is minimal at best. Because I shoot exclusively raw files, I use Adobe Camera Raw (ACR), commonly called Bridge, to open my files. I do not use Lightroom or Photoshop Elements, and I have never used Apple's Aperture. My time spent in Bridge is brief. Sometimes I fine-tune an image's white balance, open up the shadows a bit more, or add some black or white. On rare occasions, when I have failed to use my Lee 3-stop graduated or tobacco graduated neutral-density filter, I might call upon Bridge's built-in Graduated Neutral Density tool

to compensate. I then select "open" and send the image(s) to Photoshop. After that, as so many students have witnessed when we process images at the end of my workshops, my postprocessing workflow begins and ends with Photoshop's Selective Color tool.

You have no doubt noticed that when you load your raw files into Adobe or Lightroom, they seem to lose whatever little bit of luster they had. It's not until you do some adjusting of the color that you start to see a semblance of what you saw when you recorded the exposure in-camera. In my many discussions with students, I've learned that most solve this issue by calling upon the seven members of the Photoshop color correction family: Vibrance, Hue/Saturation, Color Balance, Black and White, Photo Filter, Channel Mixer, and Color Lookup. And it's true that all of these tools can be used to manipulate color in your composition, for better or worse. But what may surprise some of you is that I have never used color lookup or the channel mixer, have only sparingly used the colored photo filters, and have used the black and white tool maybe once or twice. The only tool I have found that renders the vivid and *believable* colors I grew accustomed to when shooting films such as Fujichrome Velvia and Kodak's E100VS is Selective Color—and it does so without any noticeable pixilation or halos, which occur commonly when using the Vibrance and Hue/Saturation tools.

Selective Color not only does an amazing job of adding black and punching up overall contrast, but it can be used to selectively add (or subtract) a specific color, such as red, blue, or green, only to those areas that are already red, blue, or green. Want to punch up the blue sky? Just move the blue slider 100 percent to the left. Want to punch up the green forest? Move the green slider 100 percent to the left. Sometimes my use of Selective Color is quite liberal, other times more conservative.

 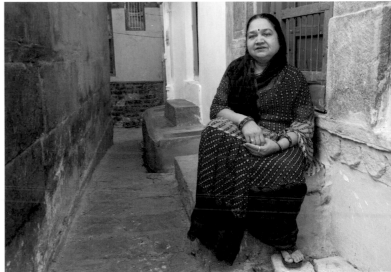

Almost every image in this book had a short but necessary appearance on what I call the postprocessing stage, and every image had a short and necessary stop at the Selective Color booth, whose impact is shown clearly in this pair of images.

Both images: Nikon D810, Nikkor 24mm–120mm lens at 35mm, *f*/11 for 1/200 sec, ISO 320

Yes, I'm aware of the Hue/Saturation/Luminance tools in Lightroom and Adobe Bridge, but as many of my students will attest, no matter how much they mess with those sliders in Lightroom or Adobe Bridge, *only* Photoshop's Selective Color seems capable of bringing out the most vivid colors.

To use the Selective Color tool, bring your image into Photoshop and select Layer > Adjustment Layer > Selective Color. Once you open Selective Color, you will see four lines with sliders in the middle. At the left ends of these lines you will see the letters C (cyan), M (magenta), Y (yellow), and K (black). On the first slider, directly opposite the letter C but *not* labeled, is the color red. On the second slider, directly opposite the letter M, is the color green. On the third slider, opposite the letter Y, is the color blue. And finally, on the fourth slider, opposite the letter K, is the color white.

For example, let's assume you want to add a bit

more red to all of the colors in your composition that are *relative to red*. Click on the pull-down menu to select "red" and then move *only* the top slider— the one that corresponds to red—in the *opposite direction* of red. In other words, move that slider toward the letter C. As you do, you will notice that all of your reds—and *only* your reds—are noticeably more vivid. You decide how much more vivid you want your reds to be. Assuming your composition also has a few other colors, such as blue and yellow, you would then click on the pull-down menu to select "blues" and move only the third slider (where yellow and blue are found), toward Y (yellow) to add blue. (You might then do the same for "cyans.") To add yellow, click on the pull-down menu to select "yellows" and move that same third slider toward blue. If this sounds confusing, I encourage you to access my online video tutorials at youkeepshooting.com/understandingcolor.

All that said, I am not averse to creative experimentation. I do, at times, use the Hue/ Saturation tool, the Replace Color tool, and the Color Balance tool—not for color correction, but to stretch the boundaries of an image or change a color entirely. I've included some examples of that here as well, in case you wish to experiment on your own images.

I have never been disappointed by the views from the decks of my rooms at the Swissôtel in Singapore, which have fallen on a variety of floors from the thirty-sixth to the fifty-third. (Note that a new policy has banned deck use above the thirty-eighth floor. So if you want to shoot from your deck, request a harbor view on that floor or lower.)

One afternoon, I looked outside to see two workers doing maintenance on one of the two rooftops of the Esplanade Theater (often called the "two big durians," referring to the fruit with similarly textured skin). Behind the workers is the bay, with numerous white prayer balls floating in the water. It is a monochromatic, multipattern composition the focus of which is, of course, the two workers.

The color of the workers' clothing was actually blue, not red, but I wanted the more contrasting red. I went

to Layer > Adjustment Layer > Hue/Saturation, then selected "blue" from the hue/saturation tool and moved the top "hue" slider to the right until the blue coveralls were red. Next, I made a mask (with the color palette showing white in front), selected my paintbrush tool from the toolbox, and painted over the worker's coveralls to expose the red layer beneath.

Images 1 and 2: Nikon D7100, Nikkor 24–120mm lens at 85mm, f/11 for 1/320 sec., +2/3 due to overall white subject; Image 3: Nikon D7100, Nikkor 200–500mm lens at 320mm (creating an effective focal length of 480mm due to D7100 1.5 crop factor), f/13 for 1/200 sec., ISO 640; Image 4: Nikon D7100, Nikkor 200–500mm lens at 470mm (creating an effective focal length of 705mm due to D7100 1.5 crop factor), f/13 for 1/200 sec., ISO 640

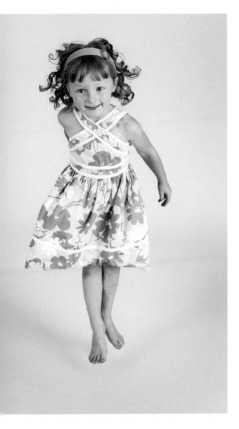 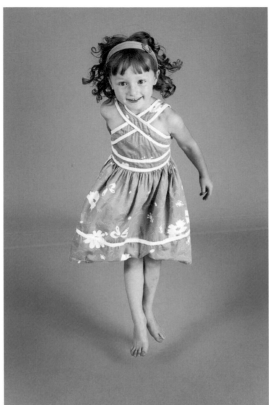 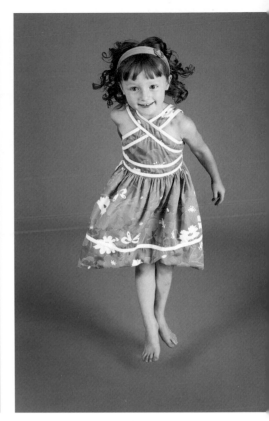

In this example, the original image is of a charming redhead (my adorable niece) jumping on a yellow seamless paper background. All I wanted to alter was the yellow color found in the background and dress.

To do this, I chose Image > Image Adjustment > Hue/Saturation. I selected "Master" in the upper-left-hand corner and selected "yellow." Then I simply moved the hue slider until orange/peach replaced the yellow in the original image. After saving my image, I returned to the original and repeated the process to get pink. Each hue gives the portrait a different feel: yellow is

fun and cheerful, orange is warm and inviting, pink is playful and sweet.

Note that the Hue/Saturation tool should only be used for changing the hue, not the saturation. Adjusting the saturation slider often leads to pixilation and halos, cheapening the look of your photograph. To increase a color's saturation, call upon the more believable Selective Color tool. —SUSANA

Canon EOS 1D Mark II, Canon 28–300mm lens at 40mm, *f*/7.1 for 1/250 sec., ISO 100, studio strobes

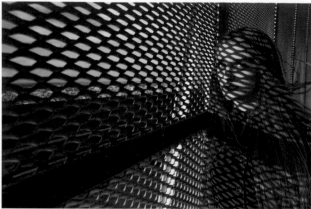

What if you don't like your model's hair color? Just send that person off to the Photoshop beauty parlor, found in this case at Layer > New Adjustment Layer > Color Balance. For the first image shown here, I moved the top cyan/red slider about halfway toward red, then moved the bottom slider about halfway toward yellow. At this point the entire picture had an orange/red cast, but not

to fear: we are about to make it all vanish. Next, I added a mask (with the color palette showing white), selected the paintbrush from the toolbox, and painted over the model's hair, transforming her from a blonde to a redhead.

Both images: Nikon D800E, Nikkor 24–120mm lens at 50mm, f/16 for 1/100 sec., ISO 200

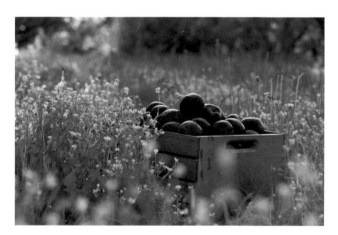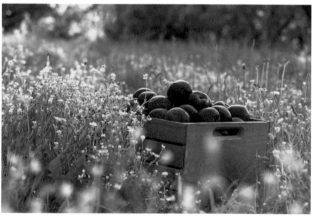

On a commercial assignment near Cuauhtémoc, Chihuahua, Mexico, I took my photography gear into an apple orchard to photograph a theme symbolic of the region. (Cuauhtémoc holds the unofficial world record for most apple trees per capita; apples are culturally iconic of the city.) As you can see, the final image was taken on a golden autumn afternoon—or was it? As revealed in the first image, it was actually a hot summer day. I rarely make drastic digital alterations to my images, but in this case, I

wanted to see if I could turn summer into fall. After opening the Selective Color tool, I selected "yellow" in the drop-down menu and moved the cyan/red slider all the way to the left. I then moved both the magenta/green and yellow/blue sliders all the way to the right. The whole process took no more than a few seconds. —SUSANA

Nikon D810, Nikkor 105mm lens, f/6.3 for 1/320 sec., ISO 250

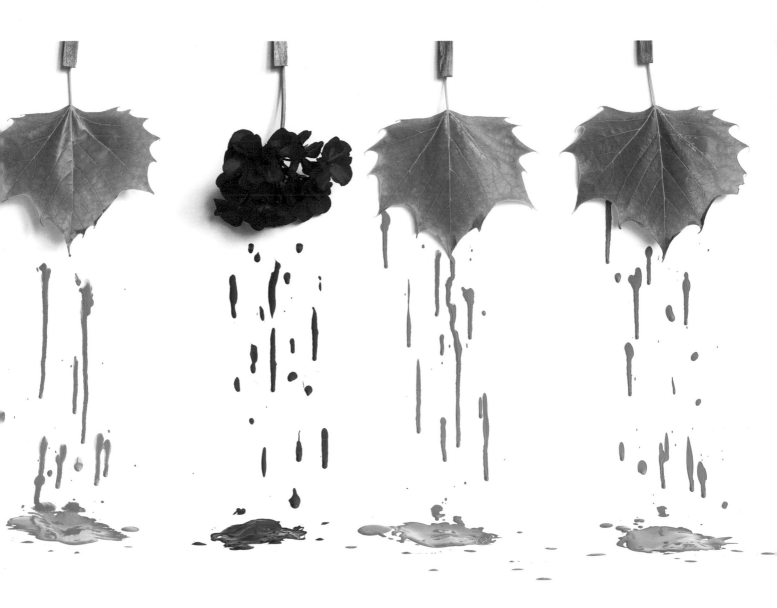

As you know by now, Bryan and I are much more about getting things right in-camera than on relying on Photoshop. In my attempt to demonstrate that much of one's creativity can be done in-camera, I wanted to share an image that is often mistaken for one created in Photoshop. In fact, this was created one hundred percent in-camera, by simply attaching leaves and flowers to a white seamless paper background with clothespins and then adding drips

of matching colored paints. Surprised? Don't be! With a little imagination and camera know-how, you really can create beautiful color images *in-camera*, time and time again. —SUSANA

Canon EOS 1D Mark II, Canon 24–105mm lens, *f*/11 for 1/200 sec., ISO 200, with two White Lightning studio strobes

INDEX

A

Additive colors, 39
Adobe Camera Raw (ACR), 130
Analogous colors, 38, 48–49

B

Backgrounds
 black, 123
 color as, 60–63
 effects of different, 74, 95
 out-of-focus, 60, 87, 95
Backlit scenes, 3, 88, 122
Black, 15, 19, 20, 38, 53, 120–23
Blue, 6, 58, 102–9
Blue hour, 2, 105, 107
Bridge, 130

C

Close-ups, 9, 76, 97
Clutter, eliminating, 36
Cold weather, 79
Color contamination, 27
Color(s)
 additive vs. subtractive, 39
 advancing vs. receding, 58–59
 analogous, 38, 48–49
 black and white vs., 2
 complementary, 38, 41–47
 exposure and, 18–21
 favorite, 74, 102
 learning to see, 8
 light and, 12, 15–16
 power of, 1, 32–33, 35–36, 37
 primary, 37
 psychology of, 74
 as seamless background, 60–63
 secondary, 37
 tertiary, 37
 thinking in, 2
 triadic, 38, 39
 visual weight and, 32, 40, 53–54, 56–57
 See also individual colors
Color temperature, 22
Color wheel, 37–40
Complementary colors, 38, 41–47

D

Depth of field, 53
Digital photography
 characteristics of, 2, 4
 progress in, 5

E

Exposure, 18–21, 28. *See also*
 Overexposure; Underexposure

F

Filters, 1–2, 126–28
Flash, 82, 99
Foregrounds, out-of-focus, 64, 65

G

Green, 49, 58, 96–101

H

Hues, 38

I

Interiors, 24–25

K

Kelvin scale, 22

L

Light
 color and, 12, 15–16
 importance of, 12
Light meter, 18–21
Lightroom, 4, 5, 130

M

Macro lens, 9, 76
Magenta filter, 126, 127
Monochromatic compositions, 50–51
Motion, 66–71, 84

O

Orange, 58, 82–89
Overexposure, 19, 28, 38, 40

P

Panning, 66
People
 approaching, to photograph, 92
 capturing skin tones of, 26–29
Photoshop, 4–5, 38, 130–35
Polarizing filter, 82, 126, 128
Postprocessing, 4–5, 8, 24, 38, 130–35
Primary colors, 37
Purple, 110–15

R

Red, 2, 32, 58–59, 75–81

S

Secondary colors, 37
Selective Color tool, 4–5, 130–31, 133
Shades, 38, 40
Sidelight, 52
Skin tones, capturing, 26–29
Spin zooming, 67
"Starburst" phenomenon, 88, 105
Subtractive colors, 39
Sunsets vs. sunrises, 84, 112

T

Tertiary colors, 37
Tints, 38, 40
Tobacco-colored filter, graduated, 126, 128
Tones, 38
Triadic colors, 38, 39

U

Underexposure, 18, 28, 38, 40

V

Violet. *See* Purple
Vision, photographing your, 5
Visual weight, perception of, 32, 40,
 52–54, 56–57

W

Weather, 2, 22, 24, 79
White, 15, 19, 21, 38, 116–19
White balance, 22–25, 26, 27, 29

Y

Yellow, 58, 90–95